M000249495

IMAGES
of America

RIVER TOWNS OF
CENTRAL KENTUCKY

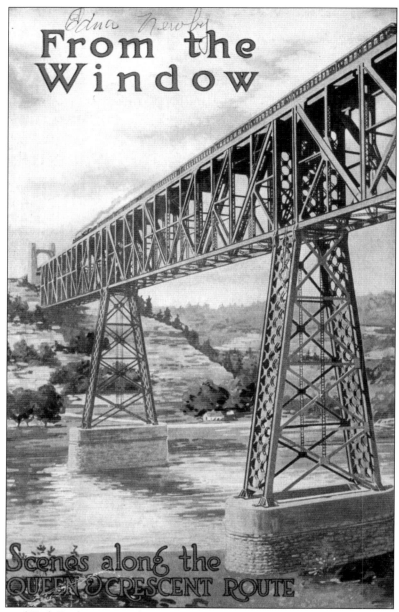

From the Window

Scenes along the QUEEN & CRESCENT ROUTE

This drawing of High Bridge appeared in an April 1912 *From the Window* book. Given to passengers of the Queen and Crescent Route special train between Cincinnati, Ohio, and Chattanooga, Tennessee, the book contained many photographs and a brief bit of information about sights that would be seen from the window by passengers on the train. (Courtesy Ken Houp.)

ON THE COVER: While many steamboats once plied the Kentucky River, the *Falls City II* was the most well known of the vessels to ply the river in the late 19th and early 20th centuries. The steamer was a prime example of what was often referred to as a packet boat because it carried both cargo and passengers, and operated on a set schedule. (Courtesy Kentucky Historical Society.)

IMAGES
of America

RIVER TOWNS OF
CENTRAL KENTUCKY

Melissa C. Jurgensen

ARCADIA
PUBLISHING

Copyright © 2008 by Melissa C. Jurgensen
ISBN 978-0-7385-6705-1

Published by Arcadia Publishing
Charleston SC, Chicago IL, Portsmouth NH, San Francisco CA

Printed in the United States of America

Library of Congress Catalog Card Number: 2008931396

For all general information contact Arcadia Publishing at:
Telephone 843-853-2070
Fax 843-853-0044
E-mail sales@arcadiapublishing.com
For customer service and orders:
Toll-Free 1-888-313-2665

Visit us on the Internet at www.arcadiapublishing.com

Louisville native Melissa C. Jurgensen is an author, executive legal secretary, and photographer. Melissa is the webmaster of www.MelissaJurgensen.com and www.KyCoveredBridges.org. An extensive world traveler, she has had a lifelong interest in the history of the communities of her home state of Kentucky. In 2006, Melissa received the commission of Kentucky Colonel, the highest honor in Kentucky, from Gov. Ernie Fletcher.

CONTENTS

ACKNOWLEDGMENTS

First and foremost, I would like to thank Kentucky artist Paul Sawyier. If it were not for his artwork, I never would have discovered High Bridge.

A big thank-you goes out to everyone who contributed photographs or who took time to share a memory with me for this book: Amalie Preston, Anna Armstrong, the Woodford County Historical Society, Ken Houp, Clyde Bunch, the Kentucky Historical Society, Joyce Hardin, www.RiverboatDaves.com, the Shaker Village of Pleasant Hill, Bill Coffey and the Paul Sawyier Art Galleries, Jerry Sampson, the Lexington Public Library, the University of Kentucky Archives, Ellis Hudson King, and the Bluegrass Railroad Museum.

Also thanks to my parents, my brother Mike, and Judy and Brian Jurgensen for supporting me throughout this project, and for going here, there, and everywhere with me to help me research and find and take photographs. Last but not least, I would like to extend my appreciation to all who have offered their encouragement to me during this entire project.

Unless otherwise noted, all images were either photographed by or are from the collection of the author.

FOREWORD

While many books have been written about the Kentucky River, there are yet countless stories waiting to be told. Melissa Jurgensen in Lexington is resurrecting the pictorial and oral history of the Kentucky River, from Tyrone to Clays Ferry, linking the villages and landings on its banks into a long and winding community stitched together by ties of commerce, family, and friendships.

I come from a family who lived near and drew their sustenance from the river for generations. Some of my earliest and fondest memories have the Kentucky River as a backdrop. In my Mercer County home high on the plateau above the river, the mustached visage of my great-grandfather, Capt. S. J. Preston, stares solemnly down from the wall. To a child, he seemed larger than life as I listened to tales of his exploits piloting steamboats, facing down desperadoes, or dabbing the rope and pulling fully loaded barges into the lock pits.

I can still hear the strains of "Shall We Gather at the River" ringing out through the open windows of the old Oregon church during revival meetings and blending with the lazy alto tones of the river as it rolled past. How quickly the alto changed to a deep angry bass as the river swelled to flood proportions, swirling through barns, houses, and stores. Like the Nile, when the river had vented its wrath, it would settle back into its channel leaving as an apology a new layer of rich soil in the river bottoms.

I often spent Sunday afternoons playing on the only street in Oregon and visiting with aunts, uncles, grandparents, great-grandparents, and cousins once, twice, and three times removed. Family in Woodford County, cut off from family in Mercer County by the closing of the ferry in 1937, would come down to the riverbank and call out for someone to bring a foot boat and set them over so they could visit. Adults gathered on Uncle Redmon Moore's two-swing front porch, watching the children play and spinning yarns about the fish getting drunk when the distillery at Camp Nelson burned. They spoke of a time before the dams when trees almost touched at midstream, and one could ford the river at Landing Run Creek. They remembered well the sound of the calliope heralding the arrival of the showboat, or tying a flag at the river landings to signal the steamboats to stop and pick up goods or passengers. They felt connected to the rest of the world when the scrap metal boat came upriver during World War I, exchanging pretty baubles for precious iron for the war effort.

In the loft of our barn, I would open the creaking lid of my grandmother's trunk and read old postcards from relatives and friends all along the Kentucky River. I pondered life before the telephone or automobile, when the river was a wonderful liquid highway.

Now I ponder a new community stitched together by the Kentucky River whose common bond is the need for water. Often their only connection with the river is the purified stream coming from their faucets. Perhaps as they read this book, they will see this water, beginning with the rains of eastern Kentucky, flowing over submerged logs from the timber industry, eddying around sunken barges and steamers, and cascading over dams built with the labor of man, mules, and steam. Perhaps this new community will rediscover and fully appreciate their river!

—Amalie Preston

INTRODUCTION

The Kentucky River flows in a northwardly direction from Barbourville up to the Ohio River. While the river meanders its way through Kentucky, it passes through many towns and through some of the most picturesque countryside in Kentucky, such as the white limestone cliffs, or palisades, which are some of the oldest exposed-rock formations in the commonwealth. These gleaming white cliffs, some towering as much as 400 feet above the river, and the river itself caught the eyes of early pioneers traveling through the uncharted territory of Kentucky. It impressed some so greatly that they decided to settle along the banks of the river.

It was in the early days of statehood that some of these settled areas grew into the communities of Tyrone, Oregon, Mundy's Landing, Brooklyn, High Bridge, Camp Nelson, Valley View, and Clays Ferry. While these villages were not the largest in their respective counties, nor did they boast the greatest populations, they played an integral role in shaping the history of the state. In the days before the railroad and automobile, the river was the main source of transportation, beginning with the early flatboats and evolving into steamboats and barges.

During the years before the U.S. Army Corps of Engineer's lock and dam system, the river was impassable during certain months of the year due to shallow water. Supplies could not reach the villages. However, the settlers did not suffer. The lush wilderness around the river teamed with wildlife, and the rich soil was ideal for farming, which supported the river inhabitants until water traffic resumed. Such abundant local goods were also sold by farmers and exported to the city aboard the many steamboats that once plied the Kentucky River trade.

Commerce boomed along the river between Tyrone and Valley View with the completion of the locks and dams in that area in 1903. The entire lock and dam system on the Kentucky River was completed in 1917, allowing the river to be navigable year-round.

The beauty of the cliffs and the charm of the communities alongside them drew writers and artists such as Paul Sawyier, who lived in a houseboat on the river and painted scenes between Camp Nelson and High Bridge from 1908 to 1913. Even after relocating to New York in 1913, Sawyier continued to paint scenes from his beloved Kentucky River up until his death in 1917. (An interesting side note is that residents of High Bridge would often say among themselves that Sawyier was lazy because he did not farm for a living, he only painted, which was unheard of in that era along the river.)

As word spread of the beauty of this area along the Kentucky River, tourists from cities such as Louisville, Kentucky, Cincinnati, Ohio, and as far away as Indianapolis, Indiana, would travel aboard steamboats and, in later days, by rail to marvel at the cliffs and the green landscape that were in striking contrast to the starkness of their home cities. These out-of-towners brought even more commerce to this area.

The dawn of the railroad made traveling easier. In the case of High Bridge, once a tiny village known as North Towers, it actually spawned the community itself with the construction of a wondrous railroad bridge in 1877 that many came to see.

Showboats would come down the river from the mighty Ohio River. The music from the calliopes, echoing off the palisades, was heard for miles before these novel vessels were even seen. Operas, plays, and, in later years, silent movies were shown aboard these vessels, often telling stories from far-off foreign lands, which undoubtedly sparked the imaginations of young and old alike.

However, with the spread of the railroad, the era of the steamboat began to fade. In the early 20th century, the days of the railroad as a source of passenger transportation became numbered with the introduction of the automobile. Some of these communities faded almost immediately. Yet some such as Camp Nelson and Brooklyn held on and attempted to adapt to the progressive changes that were taking place. However, as roads began to improve, and with the introduction of the interstate highway system in 1956, these communities also disappeared due to the lack of commerce on the river and back roads. The residents began to move to cities such as Lexington in search of employment and a better way of life.

This book will take you on a pictorial journey through the communities of Tyrone, Oregon, Mundy's Landing, Brooklyn, High Bridge, Camp Nelson, Valley View, and Clays Ferry. On your journey, you will meet some interesting residents and visionaries that breathed life into these communities, helped create their unique charm, and brought much needed commerce to the area. Though much of this book highlights the halcyon days along the river in the heyday of these villages, it will also document the changes brought on by time and their ultimate demise. While some of these communities live on in the memories of the old folks who live along the river and in old family photographs, others are merely passed through by individuals who do not know of their once vibrant history. For example, did you know that Brooklyn was once home to the gentleman who later went on to develop weapons that are still being used by the U.S. military? That at one time the highest railroad bridge over a navigable waterway in the world crossed the Kentucky River at the Jessamine/Mercer County line? That its replacement was designed by the designer of New York City's Hell's Gate Bridge? That a legendary riverboat captain once called the now defunct village of Oregon his home?

Still, not all of these communities have been condemned to the history books. The community of High Bridge has, in recent years, experienced a rebirth that will hopefully cement it into the hearts of modern visitors to ensure its survival for generations to come.

I hope you find this volume to be as interesting and enjoyable to read as it was for me to research and write. To me, history is not merely black and white facts; that is only part of the story. People made places special and breathed life into the communities, and it is important that their memories are preserved because without them, the history would not have existed.

One

TYRONE

Like many of the villages along the Kentucky River, Tyrone was an integral part of commerce for Anderson County and Woodford County. The village of Tyrone itself lay on the Anderson County side of the river about three miles from Lawrenceburg. The Tyrone area was first referred to as Streamville by the many steamboat captains who plied the river. In 1882, the first post office opened in the village, and the town was renamed Coke in honor of the postman. When Irishman James Ripy became proprietor of a distillery located there in 1883, he changed the name of the distillery to Tyrone, reflecting the name of his home county in Ireland. As the distillery became more prosperous, the town itself adopted the name given to the distillery.

Tyrone also gained regional fame by being the home of Young's High Bridge, a railroad bridge completed in 1889 that connected Lawrenceburg to Lexington by way of Versailles. The rail line competed with the Louisville and National Railroad's Louisville-Lexington line.

Tyrone was not only prosperous because of the distillers found there. The scenery along the Kentucky River made Tyrone a prime excursion destination for passengers brought on the many steamboats from cities such as Louisville and Frankfort.

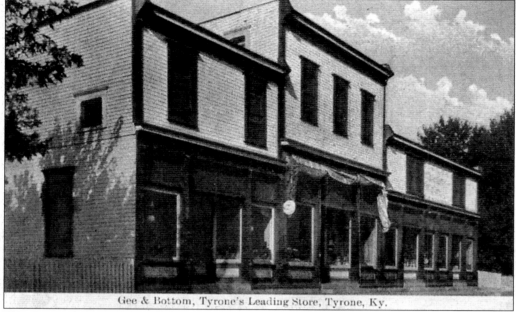

Gee & Bottom, Tyrone's Leading Store, Tyrone, Ky.

The Gee and Bottom Mercantile is an example of one of the many businesses that could once be found in Tyrone. The village quickly became a bustling port town of nearly 1,000 residents. However, due to the closure of the distilleries during Prohibition, many residents left Tyrone in search of employment.

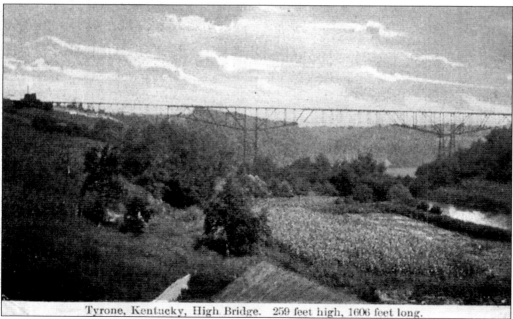

Tyrone, Kentucky, High Bridge. 259 feet high, 1606 feet long.

Young's High Bridge was completed in approximately six months, a very short amount of time considering the size of the project. Although the name of the person who designed the bridge has been lost to time, the bridge was erected by a crew of 200 men from the Union Bridge Company of New York.

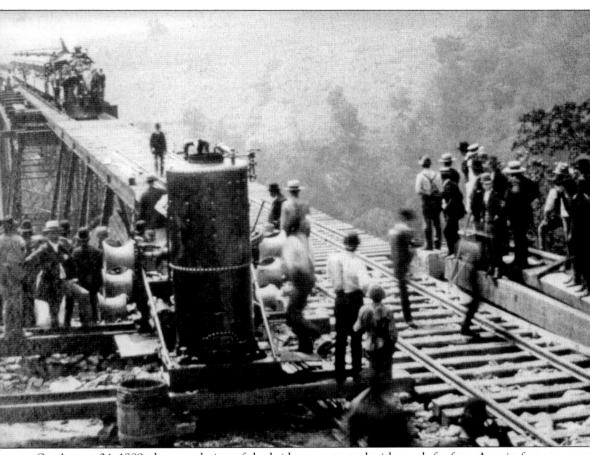

On August 24, 1889, the completion of the bridge was greeted with much fanfare. A train from Lexington stopped on the Woodford County side and one from Louisville came to rest on the Anderson County side of the bridge. Although the Lexington train arrived first, the train from Louisville was allowed to cross the bridge first because Col. William Bennett Henderson Young, the namesake for the bridge, was onboard. Colonel Young decided to ride across the bridge on the cowcatcher on the front of the lead engine, rather than inside a railcar. After the train crossed the bridge, it met the Lexington train on the Woodford County side and then proceeded to back over the bridge, followed by the Lexington train. Upon reaching the Anderson County side, both trains then recrossed the bridge and continued on to Lexington. A great roar erupted from the crowd that was in attendance to watch this spectacle. Every steamboat on the river below, undoubtedly crowded with excursionists who came for the bridge opening, sounded their whistles along with every mill and distillery in Tyrone. (Courtesy Bluegrass Railroad Museum.)

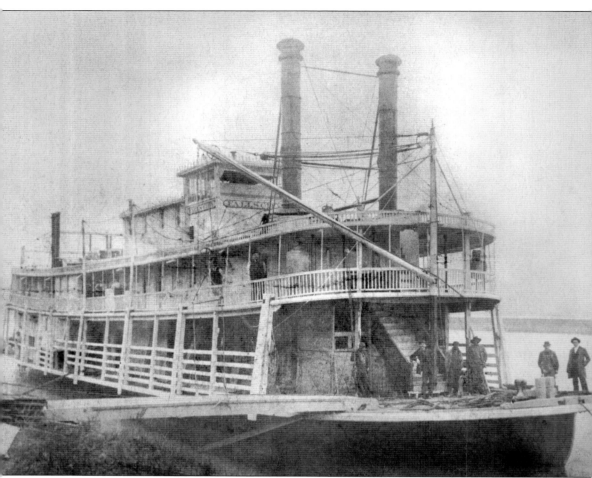

The *Falls City I* was the first of two vessels to bear that name to ply the Kentucky River trade. The ship carried freight and passengers alike from Louisville to ports such as Tyrone from 1885 to 1890. After years of continuous service, the wooden-hulled vessel fell into disrepair and was purchased by Capt. George Edgington, who used her equipment in the construction of the *Charles B. Pearce*. (Courtesy Joyce Hardin.)

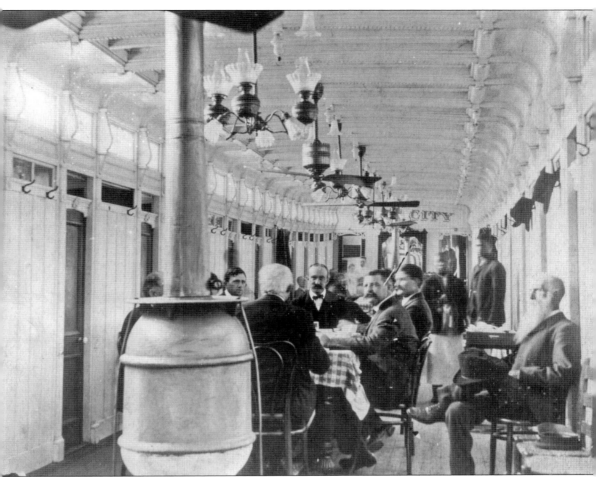

The *Falls City I* boasted such modern conveniences as electric lights and fans in her cabins. Meals were included with the ticket price or were available for a small charge. This photograph shows the main dining room. A Doctor Pryor is the bearded gentleman seated on the far right, mud clerk Charlie Webb is just above the stove, and, in the rear of the dining room, Minnie Hardin and one of her daughters are seen. (Courtesy Joyce Hardin.)

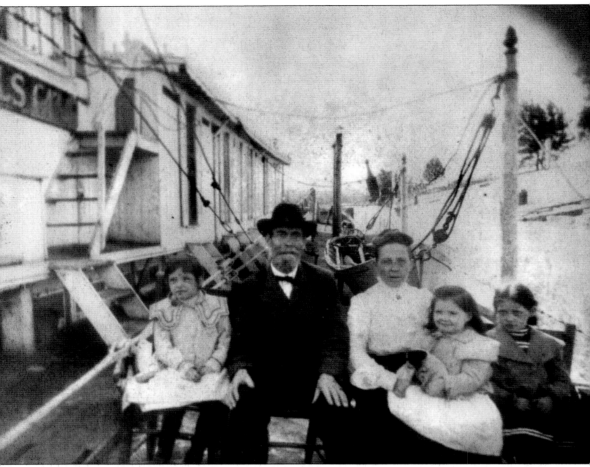

The *Falls City I* and the *Falls City II* were both owned by William David Hardin of the Louisville and Kentucky River Packet Company. The vessels were named for their home port of Louisville, which is often referred to as the Falls City because of its proximity to the Falls of the Ohio. In this photograph, the Hardin family poses onboard the *Falls City I*. Pictured from left to right are Dixie Catherine, W. D., Minnie, Elizabeth, and Minnie Allen. (Courtesy Joyce Hardin.)

This excerpt from the first logbook of the *Falls City I* notes a delivery to J. B. Ripy's distillery of one sack of hops. The entry was more than likely penned by William Dixon Preston, who served as a clerk on both Falls City vessels. This entry was from trip number 151 on November 25, 1886. (Courtesy Woodford County Historical Society.)

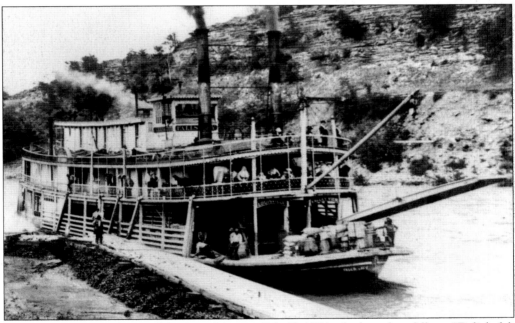

This is an entry from the *Frankfort Roundabout* on July 23, 1904, which reads as follows: "Delightful. The *Falls City II* excursion, run from this city [Frankfort] to Tyrone, on Saturday night was a great success. There was a big crowd on board, who enjoyed every moment of the trip. The boat pulled out at 8 o'clock and returned at about 11:30. There was good music and delightful dancing was indulged in by the young folks."

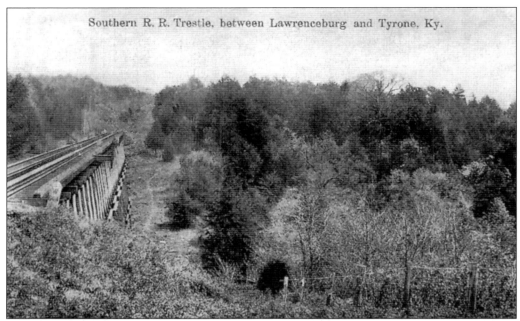

Southern R. R. Trestle, between Lawrenceburg and Tyrone, Ky.

The Cedar Brook Viaduct lies between Young's High Bridge and Lawrenceburg. This 800-foot structure is approximately 110 feet above Cedar Brook Road. Although the builder of this bridge is unknown, it is assumed that it was constructed by the Union Bridge Company, the builder of the nearby Young's High Bridge.

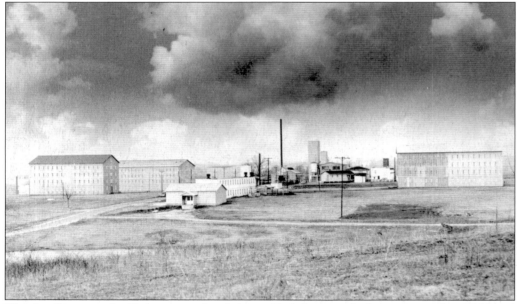

The distilleries in the Tyrone area closed due to Prohibition, which was enacted in 1920 and banned the consumption and manufacture of alcohol in the United States. The main distillery in Tyrone reopened after Prohibition was repealed in 1933, but the town never recovered. The distillery is now owned by Austin-Nicholas, the makers of Wild Turkey, and is still in operation. (Courtesy University of Kentucky Archives.)

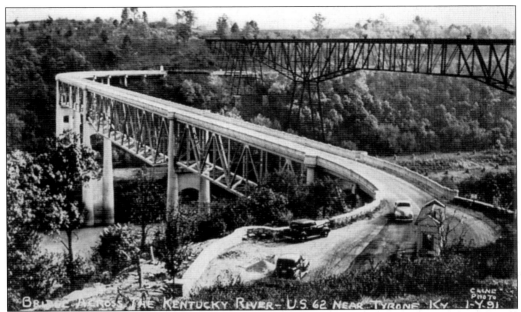

For many years, travelers between Versailles and Lawrenceburg crossed the Kentucky River on Shryock's Ferry. However, a toll bridge was commissioned by the State of Kentucky and was formally dedicated on June 8, 1932, before a crowd of approximately 2,000 people. The bridge was named for the late Sen. Jo Blackburn, a Woodford County native. The bridge became toll-free in 1945.

Located on the Woodford County side of the Kentucky River, construction on the Tyrone Generating Station began on the site in 1940. However, due to the escalation of World War II, the project was abandoned. Work resumed in December 1945, and the station began operation in 1947 and is still in use today.

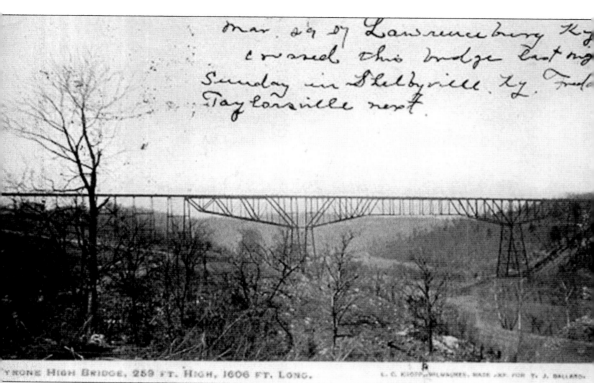

TYRONE HIGH BRIDGE, 259 FT. HIGH, 1606 FT. LONG. L. C. KLOPP, MILWAUKEE, MADE EXP. FOR T. J. BALLARD.

Named for Col. William Bennett Henderson Young, the president of the Louisville Southern Railroad, the bridge is 1,659 feet long and towers 283 feet above the Kentucky River. The increase in automobile traffic eventually rendered passenger trains obsolete, and the last passenger train crossed the Young's High Bridge on December 27, 1937. The struggling railroad was later purchased by Norfolk Southern, and the bridge was taken out of commission in November 1985.

Two

OREGON

Although the origin of the name Oregon is unknown, one thing is for certain: this small village found along the banks of the Kentucky River in Mercer County was once a thriving port along the river. The community grew as a direct result of the steamboats that traversed the Kentucky River. They brought necessary commerce to the area and on to towns like Salvisa and Harrodsburg. At one time, Oregon was home to numerous businesses, including a distillery, a hotel, many general stores, a post office, and several boatyards, including one owned and operated by popular riverboat captain Squire Jordan Preston and his family. A ferry also operated between Oregon and Warwick, a community on the opposite side of the river in Woodford County that had all but disappeared by the 1840s. However, the ever-increasing popularity of the railroad gradually rendered the steamboats obsolete. When their operation ceased, it ultimately led to the demise of Oregon.

Monday May 29 1854

255	Sam. McAfee Dr		4527 35
	1 Spelling Book	10	10
222	John H. Brown Dr		
	8 no 8 no nails	35	35
242	Miss Cynthia Riker Dr		
	10 yds Berago	4.80	
	1 " Drilling	12	
	4/4 " Bld Cotton 18	76	5.68
S	Mrs Mary Riker Dr		
	8 yds Gingham 16	2.00	
	12 " Edging	15	3.15
S	H. E. Palmer Dr		
	10 yds Jackonet 88	2.64	2.64
255	Sam. McAfee Dr		
	8 yds Blue Lawn	2.00	2.00
S	R. A. Nelson Dr		
	2 1/2 yds RK Delaine 15	150	1 50
255	Sam. McAfee Dr		
	1 yd flouncing	75	
	1 " Blue Cotton	18	93

James and Elizabeth Preston were the proprietors of the Preston General Store in Oregon. This is an excerpt from the store's logbook that denotes the goods purchased on May 29, 1854. Sam McAfee must have forgotten his shopping list because in three separate transactions on the same day he purchased a spelling book, eight yards of blue lawn (a type of linen), and then a third and final purchase of one yard of flouncing and one yard of blue cotton. (Courtesy Amalie Preston.)

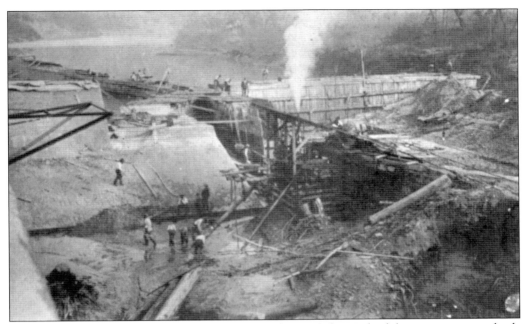

This late-1880s view of the construction of Lock No. 6 shows the labor-intensive methods necessary to build the structure. The goal for the dams along the river was to maintain a six-foot minimum water depth year-round to accommodate steamboat and barge traffic. (Courtesy Amalie Preston.)

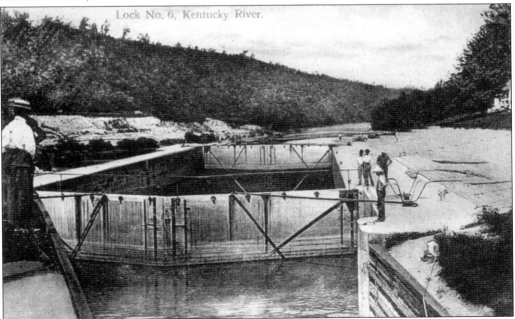

Lock and Dam No. 6, located just north of Oregon, was constructed between 1888 and 1891. The opening of the lock enabled travelers on the river to reach areas beyond Oregon that were originally only reachable during a flood tide, when high water permitted travel farther down the river for a short time.

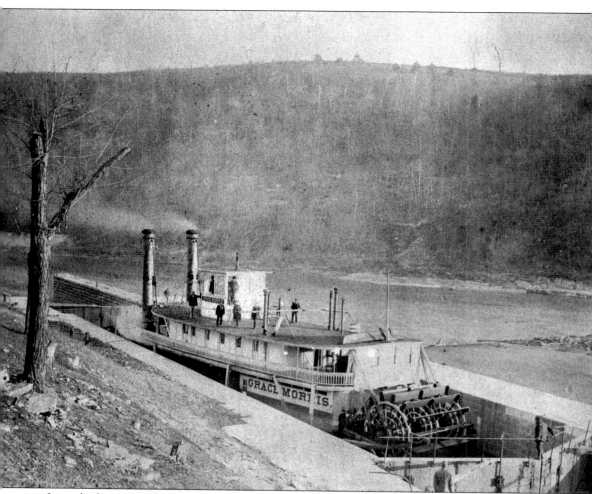

Launched in 1882, the *Grace Morris*, shown here in Lock No. 6, was one of the many packet boats owned and operated by the Preston family. In the early 1900s, the *Grace Morris* took an excursion group to Frankfort from Oregon and other landings along the way to see Barnum's Circus, which had come to town. The vessel met with a substantial delay due to a coal barge that was stuck in a lock pit at Lock No. 5, but the barge was eventually cleared, much to the relief of all onboard the *Grace Morris*. Meanwhile, the vessel had become so crowded with passengers, at least 275, that an empty flatboat was attached to the steamer at Lock No. 5 so that everyone would be more comfortable. Despite the earlier delay, the excursion party made it to Frankfort just in time for the circus, and the vessel returned to Oregon at 10:00 p.m. (Courtesy Amalie Preston.)

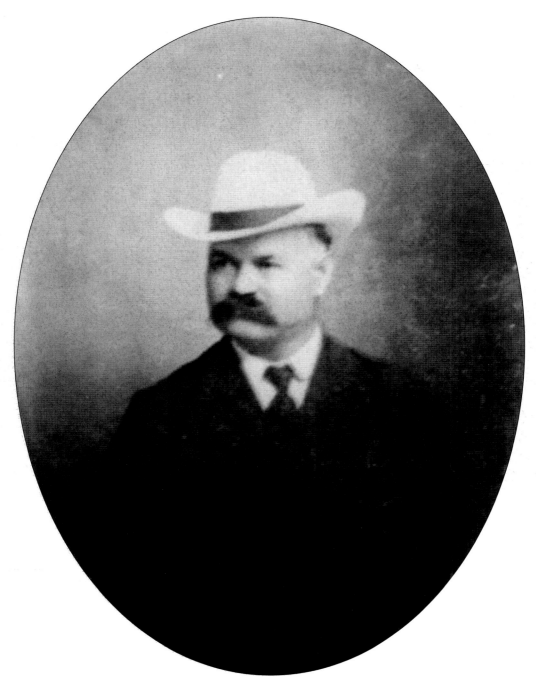

The river was the life of Capt. Squire Jordan "S. J." Preston, born in 1850. Because of his robust personality and his skills as a ship's master, a mere visit to a town or landing by a vessel under his control was a newsworthy event. In 1901, a headline in the *Frankfort Roundabout* simply stated, "Capt. S. J. Preston and Capt J. Newton Abraham of the good steamer *Falls City II* were on our streets today." Also advertisements for *Falls City II* excursions would proudly declare that Captain Preston would be at the wheel. (Courtesy Amalie Preston.)

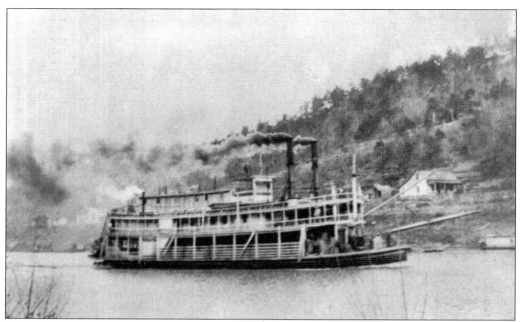

The *Falls City II* passed through Oregon frequently. During its career, the *Falls City II* was under the control of multiple masters, including Capt. Squire Jordan Preston. He operated a packet boat business with his family in Oregon from an area referred to as Captain Preston's Landing by locals. The company folded shortly after his death in 1919. (Courtesy Joyce Hardin.)

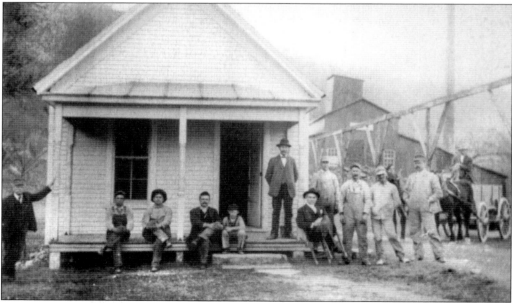

Oregon entrepreneurs and Dedman's Distillery employees pose outside the distillery office with the distillery in the background. In the photograph, from left to right, are government storekeeper Frank Nelson, George Spaulding, George Moore, Bright Kennedy, Henry Moore, Fred Terhune, John Tom Nevius, Will Terhune, unidentified, John Beatley, Capt. Squire Jordan Preston, and Aquilla Otis (with horses and wagon). (Courtesy Amalie Preston.)

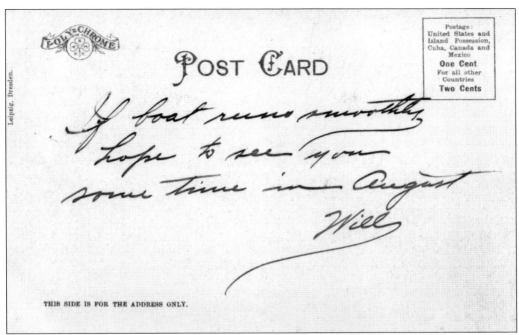

POST CARD

If boat runs smoothly, hope to see you some time in August

Will

Leipzig, Dresden.

POLYCHROME

Postage:
United States and
Island Possession,
Cuba, Canada and
Mexico
One Cent
For all other
Countries
Two Cents

THIS SIDE IS FOR THE ADDRESS ONLY.

This message is from the back of a *Falls City II* postcard wherein clerk William Dixon Preston advised his family, "If the boat runs smoothly hope to see you some time in August. Will." This card, which was not postmarked, was more than likely sent home with a delivery of goods around 1905.

The author of the above postcard, W. D. Preston, brother of Capt. S. J. Preston, kept the Preston General Store in Oregon. When needed, he was known to serve as chief clerk onboard many of the steamers operated by the Preston family, including the *Falls City II* and the *Grace Morris*. (Courtesy Amalie Preston.)

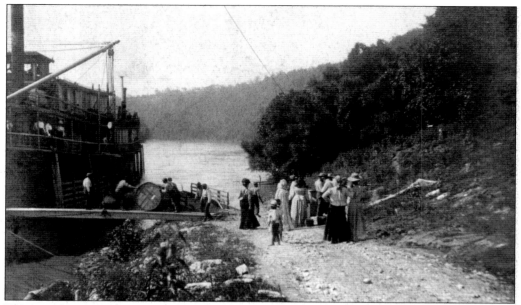

The steamboat or packet boat *Falls City II* was one of the most well known to run on the Kentucky River. The term "packet boat" refers to a vessel that carries passengers, mail, and freight, and has fixed sailing dates. Most packet boat passengers were locals traveling a short distance. However, the *Falls City II* ran excursions that brought tourists to points like High Bridge and Tyrone. (Courtesy Kentucky Historical Society.)

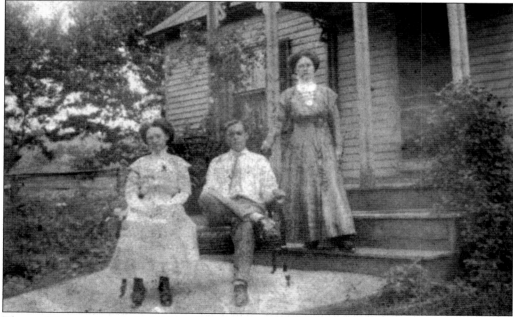

Three of Captain Preston's children, from left to right, are Myrtle Preston, John Abraham Preston (named for Capt. John Abraham), and Viola Preston outside the family home at Captain Preston's Landing. The home was destroyed by fire in the 1950s along with many historic artifacts from the family's steamboat business. (Courtesy Amalie Preston.)

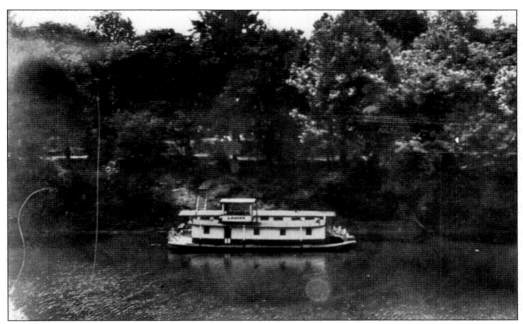

The *Louise* was one of the steamboats built by the Preston family at Captain Preston's Landing. The ship was named for a friend and faithful passenger whose last name has been lost to time. The vessel was contracted by the Corps of Engineers to serve as the towboat for their snag boats along the river as well as for other towing jobs. (Courtesy Amalie Preston.)

Built as more of a workhorse for the Preston fleet rather than a pleasure boat, this excerpt from the *Louise's* log is an example of the towing services it performed for customers, such as towing seven rafts for Norman on January 16, 1905, for $184.38, a March 2, 1905, towing for Roberts for $169.50, and a towing for Congleton for $104. (Courtesy Amalie Preston.)

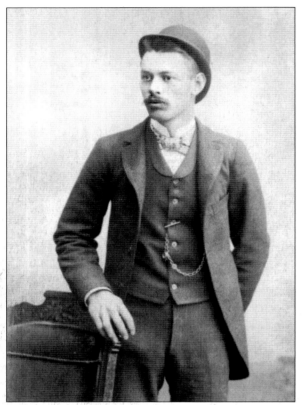

The son of Capt. Squire Jordan Preston, Capt. Edward E. Preston piloted the *John A.*, the last boat built at Captain Preston's Landing. It was named for his brother John Abraham Preston, another son of Capt. Squire Jordan Preston. In 1909, the vessel was operated as an excursion boat between Frankfort and Irvine. Capt. Edward Preston also contracted with the Queen and Crescent Route and the Louisville and Atlantic Railroads to run excursions from Cincinnati, Ohio, to High Bridge. (Courtesy Amalie Preston.)

Taken from one of the few surviving logbooks of the Preston family's shipping business, these entries from the 1908 logbook of the *John A.* list purchases for customers of paint and brushes, as well as lard and oakum, which is used in boat building. On at least one occasion, the *John A.* traveled to New Orleans in 1910 for a load of cypress wood to be used in the construction of a new church in Oregon. (Courtesy Amalie Preston.)

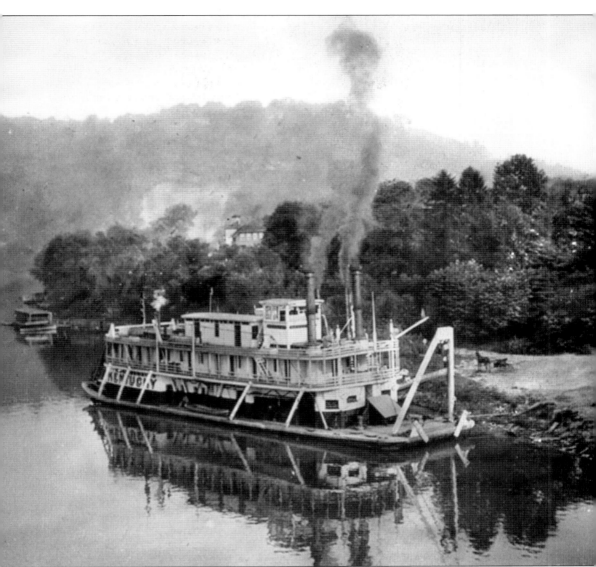

The government snag boat *Kentucky* was launched in 1909 in Jeffersonville, Indiana. It spent most of its career on the Kentucky River removing snags or submerged trees that posed a hazard to steamboat travel on the river. Snags could easily damage a hull, which oftentimes caused the boats to sink, putting the passengers and crew in peril. The *Kentucky* gained fame as the boat that rescued the survivors of the *Sonoma*, which sank in the river in 1913 near Monterey in Owen County, Kentucky, killing two people. (Courtesy Foote Collection, Lexington Public Library.)

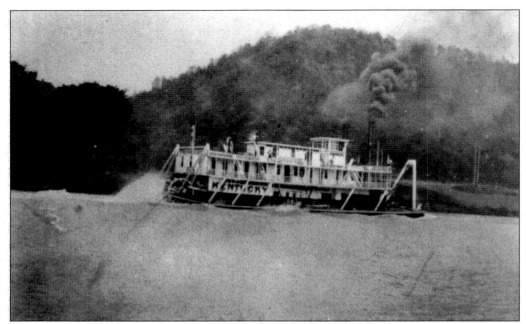

The government boat *Kentucky* passes Captain Preston's Landing in Oregon. During the boat's life, the vessel was piloted by Capt. Squire Jordan Preston and Capt. Jonathan Newton Abraham. Both were formerly captains of the *Falls City II* and other well-known packet boats of the era. (Courtesy Amalie Preston.)

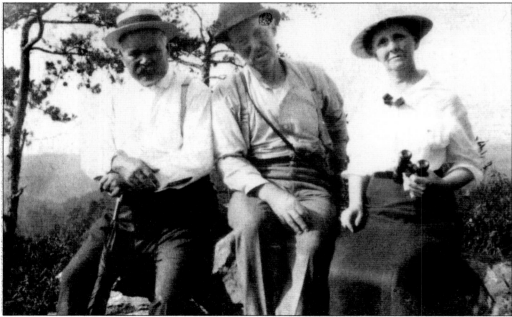

Capt. Squire Jordan Preston (left) and Capt. Jonathan Newton Abraham (center) were not only colleagues on the river, they were also great friends. This photograph was taken at Indian Head Rock, overlooking Captain Preston's Landing and the Kentucky River. Captain Abraham's wife, Dixie Vories Abraham (right), also joins them. (Courtesy Amalie Preston.)

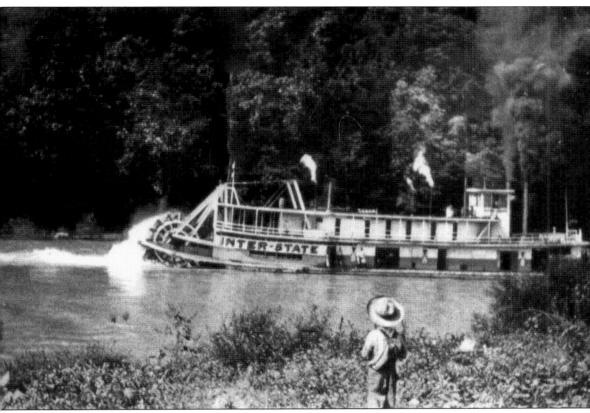

The *Inter-State* was one of many steamers in a long procession of steamboats that came through Oregon on the day of Capt. Squire Jordan Preston's funeral in 1919. As each passed Captain Preston's Landing, they reverently sounded their whistles to honor him. Many of the boats in the procession had been piloted by Captain Preston during his career on the river, which spanned many years. (Courtesy Amalie Preston.)

Known for its outstanding drama and vaudeville acts, the showboat *America* was built by Capt. Thomas Reynolds, his father, Francis Marion Reynolds, and his brother William during the winter of 1916–1917. It was pushed by the *Liberty* and later the *Attaboy* towboats. With a main floor and balcony, the *America* had a seating capacity of 300. Its shows were always well attended during its trips on the Kentucky River. (Courtesy Margaret King-Hudson.)

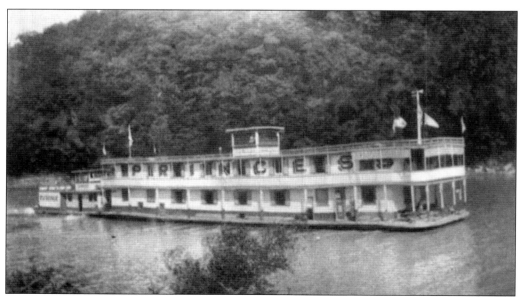

Capt. Billy Bryant's showboat *Princess* frequented Kentucky River towns such as Oregon up into the 1920s. The *Princess* featured plays and, in its latter years, newfangled motion pictures. The boat is shown here passing Captain Preston's Landing with its towboat *Florence*. (Courtesy Amalie Preston.)

Three

MUNDY'S LANDING

Munday's Landing, now known as Mundy's Landing, was originally settled in the late 1700s. It was named for local entrepreneur Thomas Munday, who was one of the first inhabitants of the area. Thomas Munday died in 1833, and his son, Jeremiah Munday, took over the business interests of his father. Jeremiah established a ferry to accommodate the highway travelers, but he had a grander dream for Munday's Landing. In 1847, Jeremiah built a large home that he opened up to serve highway and river travelers alike. The inn and tavern were an immediate success and brought prosperity to the Munday family and the surrounding community.

After Jeremiah's Munday's death, the inn and tavern were passed to his son Robert Munday, who continued their operation. Scandal struck the village of Munday's Landing in 1883, when Robert Munday was poisoned. His wife, Lucretia, and the local doctor (who became her son-in-law) were accused of the crime. The trial was highly publicized and hinged on the testimony of the ferry operator, who, it was said, could place her on the ferry the night she obtained the poison from the doctor on the other side of the river. The case against her soon fell apart after the murder of the ferry operator. She was acquitted because the other evidence against her was circumstantial, but the doctor was given a life sentence for murder. Due to her alleged role in the murder of her husband, the insurance companies refused to pay her the life insurance proceeds. She later sold the businesses and moved from the area. The ferry and the inn ceased operation in the early 1900s.

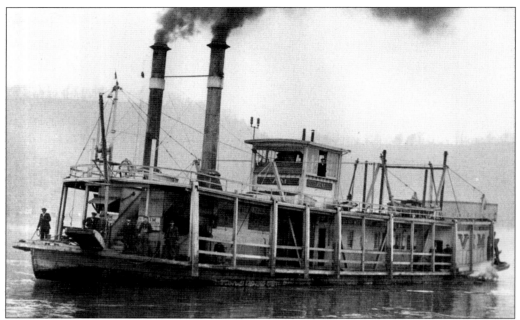

Before Lock No. 7 was built in High Bridge in 1896–1897, shallow water and a sandbar upstream made Mundy's Landing the end of the line for river travelers coming up the Kentucky River from the Ohio River. Early accounts indicate that at times, there were as many as six packet boats tied up at the dock in Mundy's Landing. However, once Lock No. 7 was completed and the steamers could pass through Mundy's Landing, business began to decline. (Courtesy Joyce Hardin.)

The white columns of Mundy's Inn were a welcome sight for weary travelers on the Versailles-Harrodsburg Turnpike and the Kentucky River. Union and Confederate soldiers stayed at the inn and utilized the ferry, although not at the same time. Built in steamboat Gothic style, the open galleries of the Mundy's Inn offered sweeping views of the river. Many visitors would pass the evenings discussing the issues of their day or perhaps just sipping a glass of bourbon in silence. (Courtesy Mercer County Historical Society.)

Four

BROOKLYN

Brooklyn lies on the banks of the Kentucky River in Mercer and Jessamine Counties. Local lore says the village was named for a Colonel Brook from Virginia, who owned a canoe made from linden tree. Colonel Brook would loan his canoe to others in the area, and the area of the river where he kept the canoe tied up was ultimately referred to as Brook's Lin Landing. Over time it was shortened to Brooklin and eventually to Brooklyn to mirror the name of the city in New York. In October 1871, the first bridge across the river was completed and was named for the town.

While most of the village was destroyed in a fire and flood in the late 1800s, the Brooklyn Bridge remained until the mid-20th century. Brooklyn held the distinction of being the site of the first highway tunnel in Kentucky. Due to the tunnel's proximity to the Brooklyn Bridge and the towering limestone palisades along the river, Brooklyn experienced a second life and supported roadside tourist-oriented businesses. By the mid-1950s, the original bridge was replaced, and road improvements bypassed the tunnel. Brooklyn was relegated to the history books.

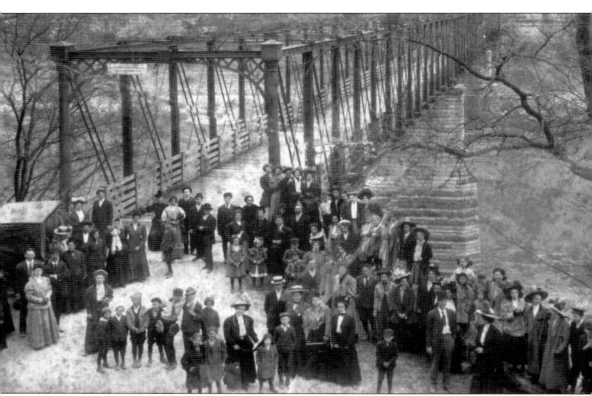

Started in January 1870, the Brooklyn Bridge was completed in October 1871. The dedication ceremony was held on October 10, 1871, when a large crowd gathered on a brisk morning among the autumn leaves along the bank of the river to witness this event. As part of the celebrations, Capt. Thomas Cogar drove the first stagecoach across the bridge and declared it officially open. (Courtesy Clyde Bunch.)

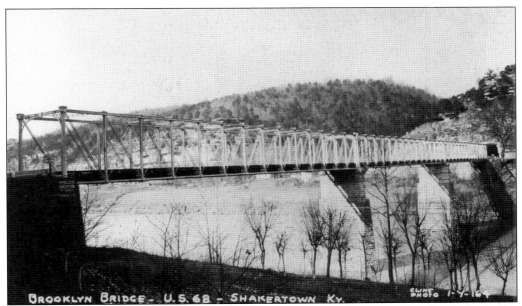

BROOKLYN BRIDGE - U.S. 68 - SHAKERTOWN KY.

While the opening of the Brooklyn Bridge aided commerce by allowing more traffic to easily cross the river, it did not bring prosperity to all. The opening of the bridge brought the closure of Cogar's Ferry, which had operated from a landing near Brooklyn since 1845.

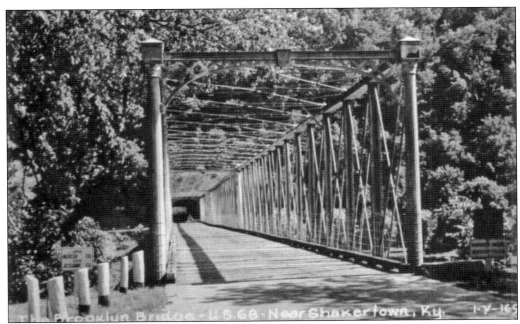

The Brooklyn Bridge - U.S.68 - Near Shakertown, Ky.

During the Tollgate Wars, a violent vigilante group known as the Tollgate Raiders formed to terrorize tollgate keepers. In reaction to their terrorist tactics, the 1896 legislature ordered counties to assume control over all toll roads and bridges, and abolish the tolls. The counties initially refused the forced buyout of the turnpike companies. However, they eventually complied due to an escalation in the violence.

After many years of serving as a toll bridge, the Brooklyn Bridge and turnpike were made free as a direct result of the Tollgate Wars that were waged in the state to combat high tolls and poor road maintenance throughout the late 1800s. However, although the bridge was now free for travelers to cross, a fine of $5 was assessed against anyone who crossed the bridge riding a horse faster than a walk.

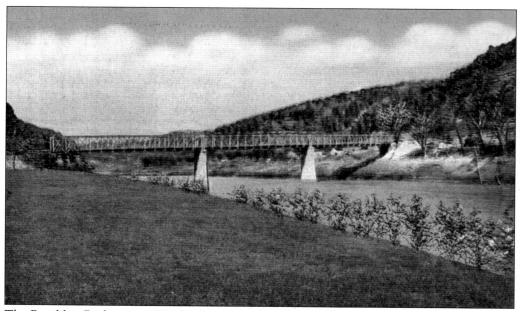

The Brooklyn Bridge was a 250-foot-long iron through truss bridge that carried the Lexington, Harrodsburg, and Perryville Turnpike across the Kentucky River. Before the construction of the Boone Tunnel immediately north of the bridge, travelers would have to pass along a dangerous projection over the cliff edge, and then the road would double back to the bridge.

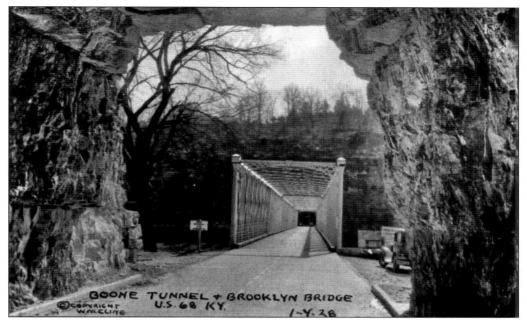

In 1926–1927, the Highway Department improved what is today known as U.S. Highway 68. As part of the improvements, the treacherous stretch of road that once led to the Brooklyn Bridge was bypassed, and a tunnel was created through the cliff immediately to the north of the bridge, allowing direct passage onto the bridge.

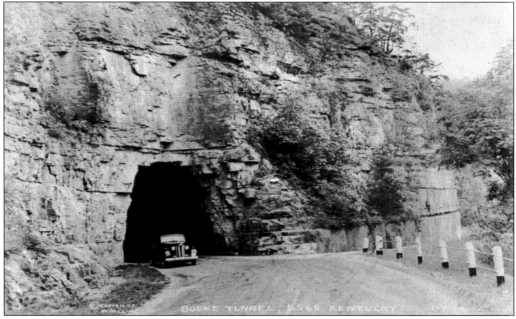

At the time the road improvements were being performed, work was underway on the nearby Dix River Dam. One of the engineers of the dam project was "Tunnel" Smith, a renowned tunnel builder. The Highway Department hired Smith to blast the tunnel through the limestone cliff, forming the first highway tunnel in the Commonwealth of Kentucky.

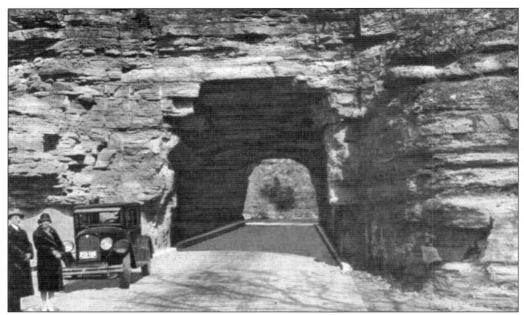

As the first highway tunnel in the state, the Boone Tunnel was the subject of many photo ops in postcards and family photographs. Visible in this photograph is a 1920s-era automobile with its occupants dressed to the nines, posing just off the Brooklyn Bridge before the tunnel entrance.

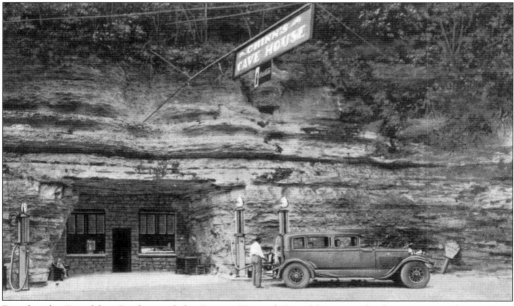

Besides the Brooklyn Bridge and the Boone Tunnel, Brooklyn was also home to another unique man-made feature: Chinn's Cave House. In 1929, Mercer County native George Chinn hired longtime family acquaintance "Tunnel" Smith, who was working in the area, to blast a cave in the side of the cliff to accommodate his novel establishment. The little girl sitting on the bench on the left of the photograph is Chinn's daughter, Anna Chinn Howells.

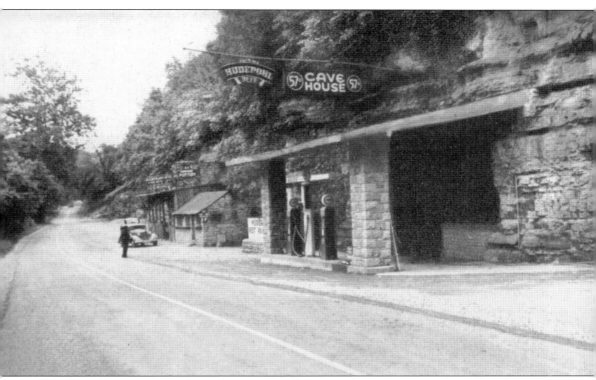

The Cave House was entirely within a man-made cave and thus was naturally cooled. Seen just beyond the gas pumps, a sign for the establishment advertised modern restrooms. The interior of the Cave House stayed at 55 degrees year-round. George Chinn got the idea for the Cave House after seeing a similar establishment in North Carolina.

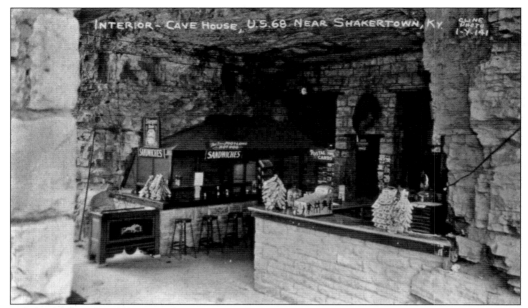

While their automobiles were being serviced, visitors to the Cave House could purchase a wide variety of refreshments (naturally cooled in the cave, of course) and candies, or stay awhile longer and dine on sandwiches or foot-long hot dogs prepared by George Chinn's wife, "Cotton." Chinn gave up his business in the early 1930s and then went on to a distinguished career with the U.S. Marines, advancing to the rank of colonel. (Courtesy Anna Armstrong.)

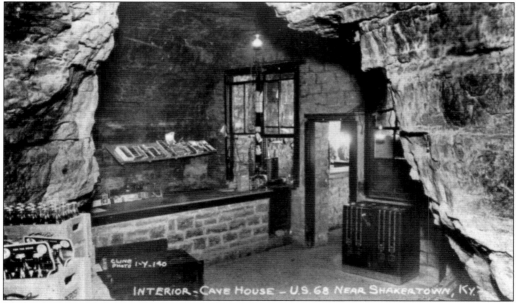

Colonel Chinn was considered one of the world's best armament experts. He is credited as the coinventor of the Mark 19 grenade launcher and other military weapons. After his retirement from the corps, he worked as a consultant for the U.S. Navy and other naval weapons developers. Many years after it was closed as a café, top-secret experimental weapons were tested in the Cave House. (Courtesy Anna Armstrong.)

Area historian Clyde Bunch recalls crossing the Brooklyn Bridge many times as a young child on fishing trips to Herrington Lake. The plank flooring of the bridge rumbled underneath the wheels of the family car. In those days, many boats still ran on the river, and he would always look for them while crossing.

Some Brooklyn residents, such as the McKinneys, a family of sharecroppers, lived high atop the cliff above Highway 68 and the Boone Tunnel. To avoid the daily trip down to the highway to their mailbox, they got creative; they had a pulley-and-rope system and would toss their mailbox over the side of the cliff to the highway below every morning and pull it up every evening to retrieve their mail. (Courtesy Anna Armstrong.)

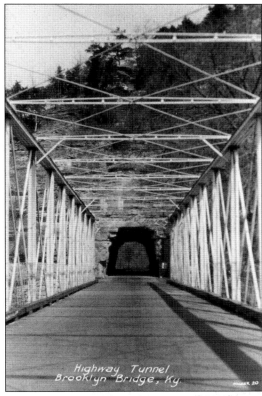

Highway Tunnel
Brooklyn Bridge, Ky.

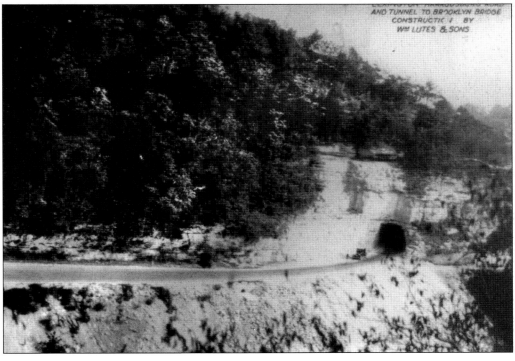

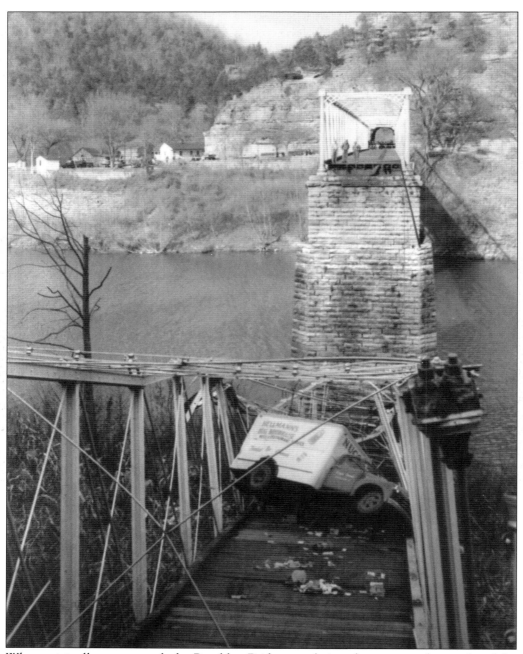

When originally constructed, the Brooklyn Bridge was designed to support the weight of the heaviest of pre-automobile traffic. However, in the 1900s, the single-lane structure began to weaken under the ever-increasing strain of automobile traffic. After 82 years of continuous service, the old structure finally failed when it was being crossed by a heavy food-service truck on November 30, 1953. (Courtesy Anna Armstrong.)

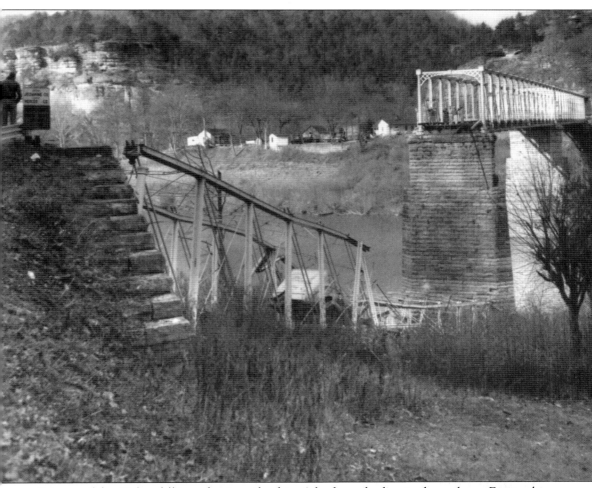

Because of the 40-foot fall into the river, the driver's back was broken in three places. Fearing his truck might catch fire, the driver was able to remove himself from the wreckage. He successfully sued the state for the unsafe bridge and was awarded $50,000 for his injuries. Kentucky governor Lawrence Wetherby stated that "no man was worth $50,000," and having the power at the time, reduced the driver's award to $10,000. (Courtesy Anna Armstrong.)

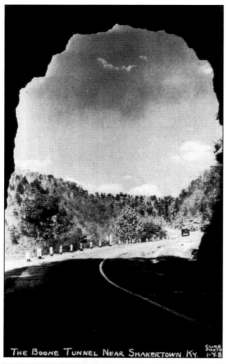

The Boone Tunnel Near Shakertown, Ky.

While recounting area memories, historian Clyde Bunch fondly recalled the Boone Tunnel, stating that no matter whom he rode with he would always have them blow their horn. He said, "That was a big thing for me as a kid." Although the Boone Tunnel now lays silent, Bunch recalls happy memories whenever he drives past it and across the new bridge completed in 1954.

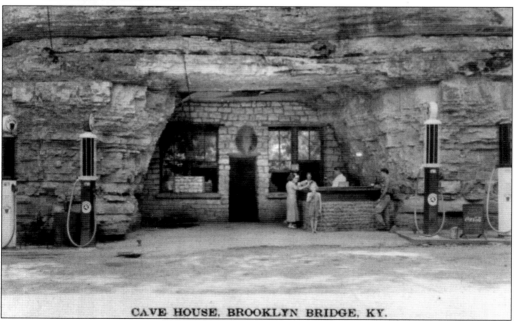

CAVE HOUSE, BROOKLYN BRIDGE, KY.

Col. George Chinn's grandson, Harold "Buddy" Howells, recounted an adolescent memory of a day in the early 1960s when, after some weapons testing inside the Cave House, with gun smoke rolling out of the entrance, a woman appeared from nowhere asking if they still served ham sandwiches. The café had been closed for a number of years, so the sandwiches were undoubtedly a memory from her girlhood. (Courtesy Anna Armstrong.)

Five

HIGH BRIDGE

In the years before the Civil War, there was a great desire for a railroad to directly connect central Kentucky to Cincinnati, Ohio, to the north and to cities in the southern United States without having to send freight to these destinations through Louisville. The Lexington and Danville Railroad Company was formed to undertake the project between those two towns, but there was a major obstacle: the Kentucky River and the limestone cliffs that ran along side it. Jonathan A. Roebling, who would engineer New York City's Brooklyn Bridge later in his life, was contracted to build a suspension railroad bridge across the river gorge at the Jessamine and Mercer County lines. Roebling began construction of the stone towers for the suspension cables in 1858, but due to the escalation of the Civil War, his massive suspension bridge was never built. His towers stood alone on the cliffs, never to be used.

Planning for a bridge resumed after the Civil War. The Cincinnati Southern Railroad was chartered in 1874 and bought out the remaining shares of the Lexington and Danville Railroad Company. Cincinnati engineer Charles Shaler Smith was engaged to design a bridge across the river. Rather than utilizing the Roebling towers, he designed a bridge to be constructed of three 375-foot spans that would rest on piers with rock footings. The building of his engineering masterpiece began in October 1876 and was completed in February 1877.

During the bridge's construction, people traveled to High Bridge, then known as North Towers, to watch the work progress. When it was open, the bridge and the area around it became a popular tourist attraction. The bridge carried trains across the Kentucky River up into the 20th century.

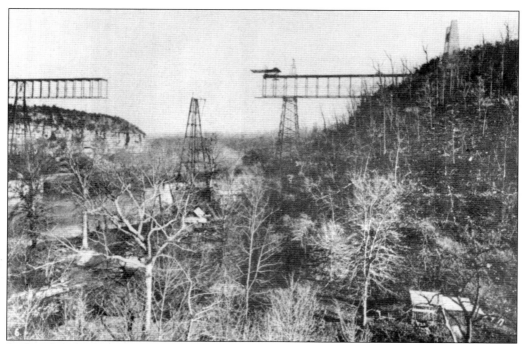

Rather than building the bridge from one side of the gorge to the other, work began on each side of the gorge simultaneously, and the spans met in the middle. This January 23, 1887, image shows the work progressing toward a temporary support pier in the center of the bridge.

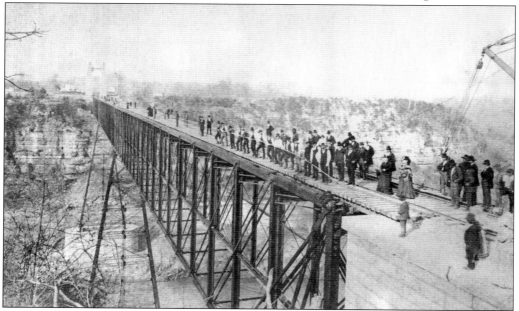

Though there were many men working on the bridge and conditions could be quite dangerous, that did not stop onlookers from traveling to the bridge to watch the progress of the work. This helped establish High Bridge as a gathering place in the hearts and minds of Kentuckians before the bridge was even completed.

Local lore has it that the bridge workers could not get the last piece of iron to go into place because it was four inches too long. When a call was placed to Charles Shaler Smith, the designer in Cincinnati, he told them to wait until nightfall because, he claimed, "if it gets as cold as I calculated it would be, it will fit perfectly." Allegedly, it did.

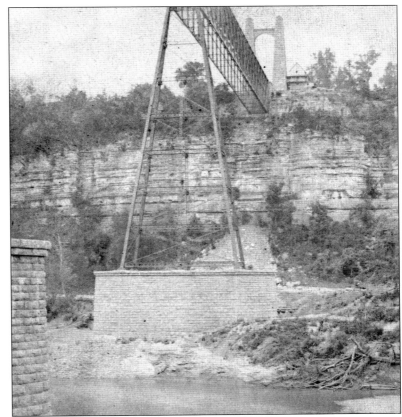

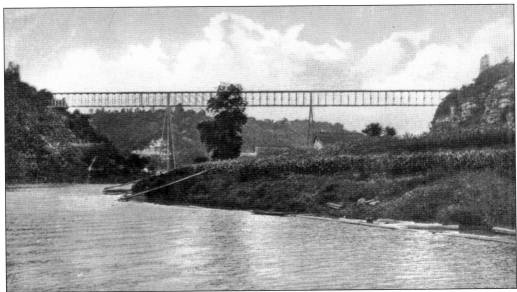

The completed bridge stood 286.1 feet above the pier base, 275 feet above the low water mark, and was 1,125 feet long. The total cost for the project is estimated between $403,000 and $411,000. Until the early 20th century, it was the highest bridge over a navigable stream in the world.

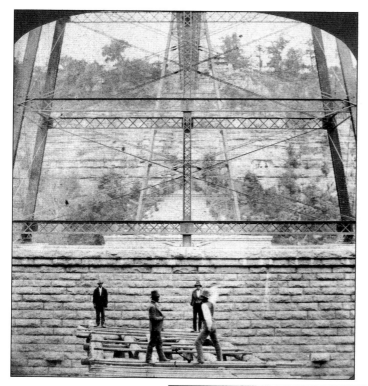

These unidentified bridge workers pose beneath the bridge in this October 1877 photograph. They are standing on the scaffolding that was used as a ramp for the large stones of the piers and later to allow easy access for workers to the steel support piers.

Photographed atop the newly constructed bridge in 1877, these well-dressed sightseers were among the thousands of people that visited High Bridge in the years to come and posed for an obligatory photograph on the bridge. The photograph was taken from the Jessamine County side looking toward Mercer County. (Courtesy Jerry Sampson.)

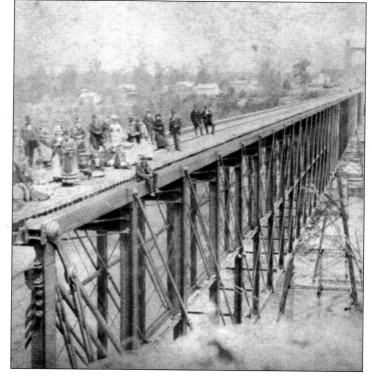

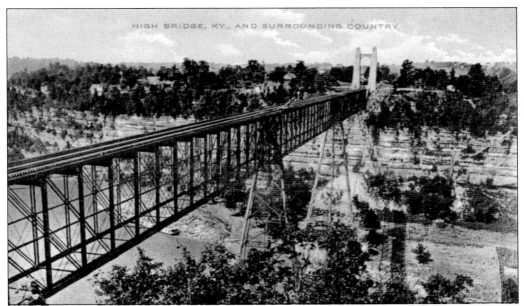

Thousands of people came to High Bridge to observe the testing of the bridge. Many came by trains, which stopped just before the untested bridge, allowing the onlookers to disembark and watch from the surrounding cliffs. Once the testing was completed, there was a large celebratory dinner where spirits flowed freely. The *Kentucky Gazette* noted that its reporter dispatched to write about the event was "barely coherent" when he returned to their offices.

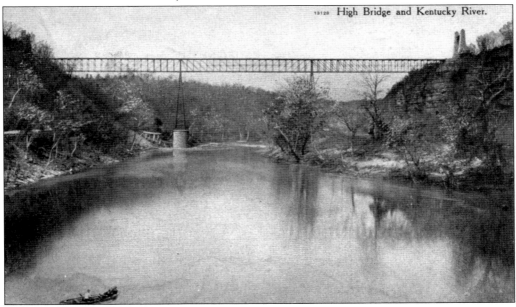

High Bridge and Kentucky River.

An April 21, 1877, *Kentucky Gazette* article chronicled the testing of the bridge. Four engines were to be used. The first two engines passed slowly over the bridge, then all four engines recrossed the bridge, meeting in the middle. The final test consisted of 24 flatcars, loaded with iron, which were backed across the bridge at 20 miles per hour and brought to a sudden stop. Gov. James McCreary spoke briefly after the tests were concluded.

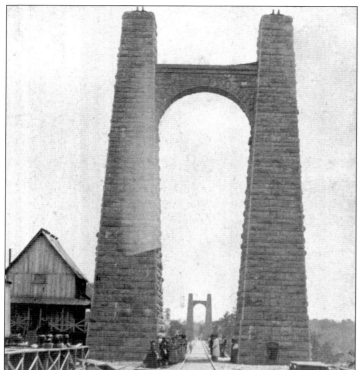

Taken shortly after the bridge was completed, one can see the expanse of the bridge between the two stone Roebling towers. The two-story building to the left of the Jessamine County tower served as an office and for storage during the bridge's construction. It served as the first depot at the site for a short time after the bridge was opened.

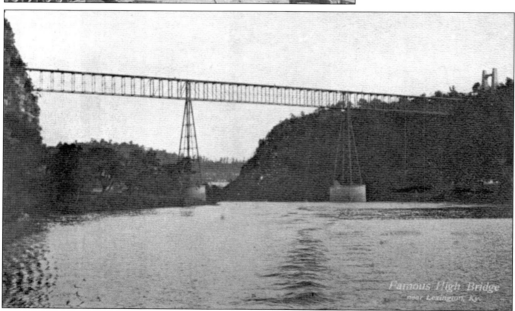

Though completed in 1877, the bridge was not formally dedicated until September 17, 1879. The dedication was a lavish event with U.S. president Rutherford B. Hayes in attendance as a guest of the Southern Railway System. The public was invited, and they could take the train round-trip from Lexington for 85¢. Despite the fact that it was "raining cats and dogs," according to the *Lexington Press*, the dedication was heavily attended.

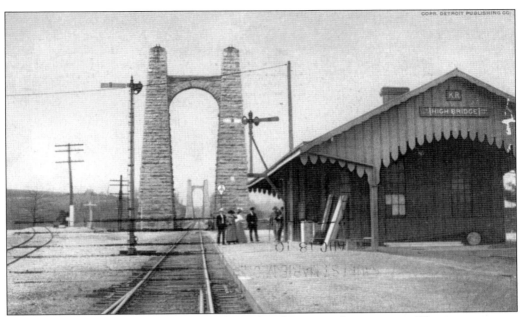

This was the first official depot at High Bridge that greeted passengers. The structure was constructed around 1877 to replace the original two-story building that was used as offices and tool storage during the bridge's construction. This was a common style of depot for the Queen and Crescent Railroad. An identical one was found in Williamstown, in Grant County, Kentucky, some 70 miles to the north.

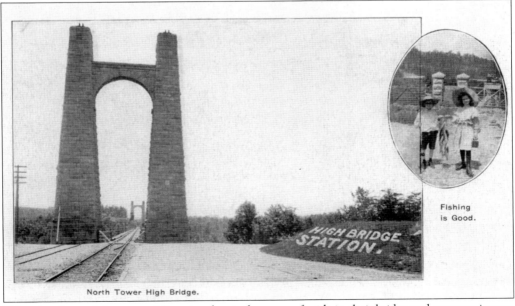

North Tower High Bridge.

Fishing is Good.

Taken just beyond the ornate Victorian depot, the sense of pride in their bridge and community can be felt by the fact that High Bridge Station is spelled out in flowers in the landscaping just before the landmark towers. The two children displaying their fish in the inset photograph are unidentified, but the photograph was taken outside the entrance to Lock No. 7. (Courtesy Ken Houp.)

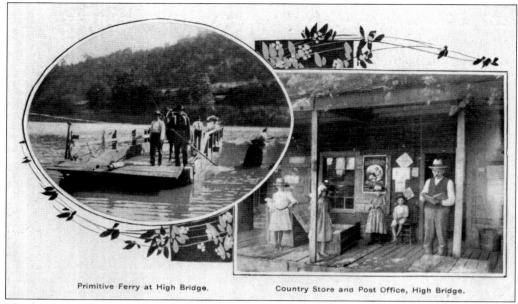

Primitive Ferry at High Bridge.

Country Store and Post Office, High Bridge.

The first post office in High Bridge was established in 1877, when the community was still referred to as North Towers. The community's name was changed to High Bridge after President Hayes's dedication in 1879. The post office remained in operation until 1976, when it closed. (Courtesy Ken Houp.)

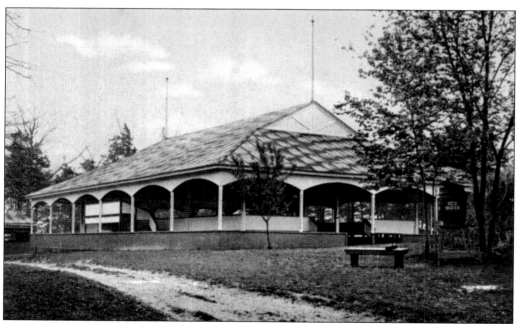

High Bridge Park was created by the High Bridge Association shortly after the bridge's dedication. The centerpiece of the park was the dancing pavilion. Many dances and revivals were held beneath its roof, and for a young lady in those days, it was a big deal if a young gentleman asked her to walk the promenade with him just outside the pavilion.

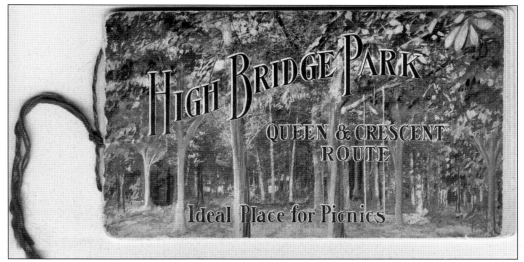

This souvenir booklet, with its exclamation that High Bridge Park was an "ideal place for picnics," was given to excursion passengers by the Queen and Crescent Railroad in the early 1900s. In the binding of the book, a long red string was included so that park visitors could tie the booklet around a button on their shirt or dress and use it as a quick reference guide to the park and not be lost. (Courtesy Ken Houp.)

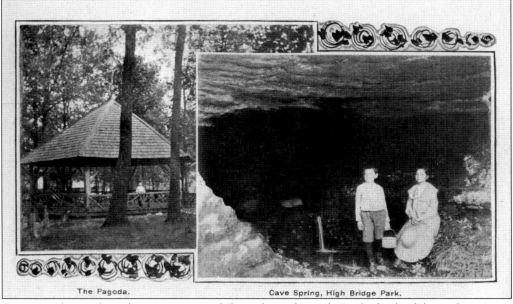

The Pagoda. Cave Spring, High Bridge Park.

Rustic gazebos such as this were scattered throughout the park. In the back of the park, one can find Daniel Boone's cave, obviously named for Kentucky explorer Daniel Boone. He frequented the area throughout his life until the time of his death in 1820. (Courtesy Ken Houp.)

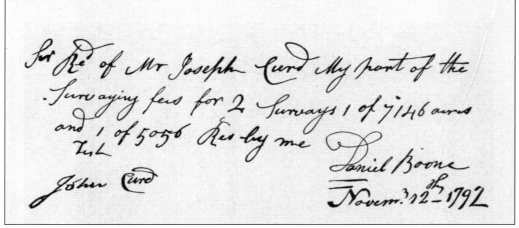

This receipt is said to be a facsimile of the receipt Daniel Boone gave to John Curd for land surveyed by him in the area on November 12, 1792. In payment for the surveying fee, Curd gave Boone land that encompassed the land used for High Bridge Park in the late 19th century. (Courtesy Ken Houp.)

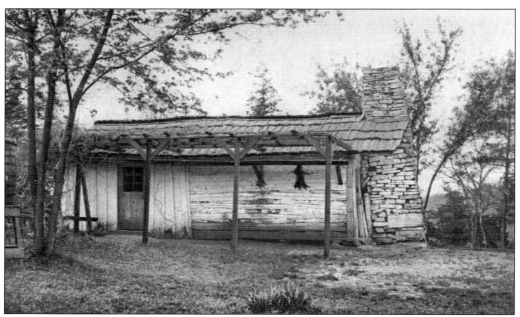

In the years before High Bridge Park, and High Bridge for that matter, Daniel Boone built a cabin on the cliff edge to stay in on his frequent trips between Harrodsburg and Boonesborough. This photograph was taken of the front of the cabin as it appeared around 1907.

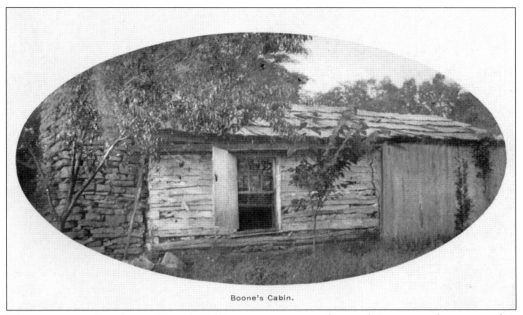

Boone's Cabin.

The structure referred to as Boone's Cabin was reconstructed several times over the course of its life, and its appearance altered. In its later years, most of the original cabin had been replaced. Only the stone hearth and a few timbers were from the original Boone-built cabin. (Courtesy Ken Houp.)

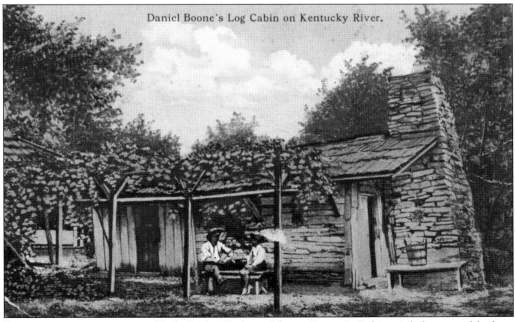

Daniel Boone's Log Cabin on Kentucky River.

For many years, campers in High Bridge Park could rent Boone's Cabin nightly or weekly for a small fee. The cabin itself was located near the dance pavilion. Today only the foundation of the cabin is visible, if one knows where to look.

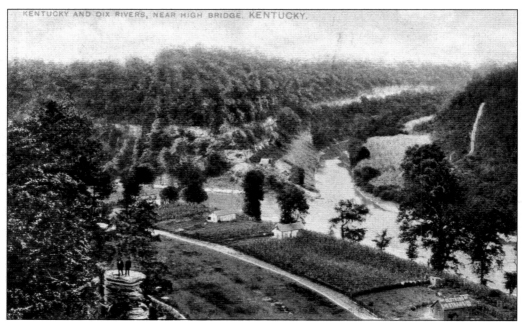

The confluence of the Dix River and the Kentucky River can be seen from High Bridge. The river, originally referred to as Dick's River, was named for a Cherokee Indian chief, Captain Dick, who was friendly with the white men that came to the area around 1769.

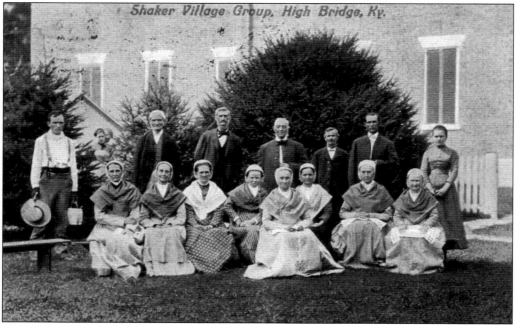

Shaker Village Group, High Bridge, Ky.

The Society of Believers in Christ's Second Appearing, also known as the Shakers for their religious trance dancing, at one time owned 4,500 acres of land on both sides of the Kentucky River. The Shakers in their nearby village of Pleasant Hill played host to the many land-tourists who came to see High Bridge through the early 1900s.

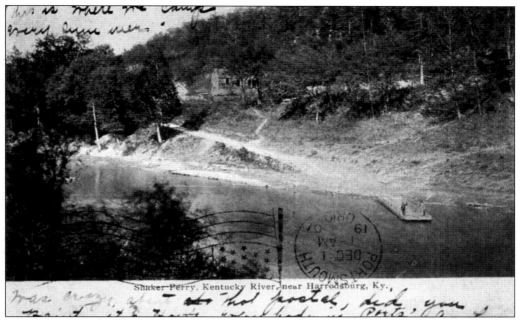

Shaker Ferry, Kentucky River, near Harrodsburg, Ky.,

The Shakers bought what is today known as Shaker Ferry Landing from the heirs of Newton Curd. They began operating their ferry in 1830. Starting in 1854, they extensively improved the road down the cliffs in Mercer County to their ferry using dynamite to blast away portions of the cliffs. This work was completed in 1861, which increased the amount of traffic across the river on their ferry.

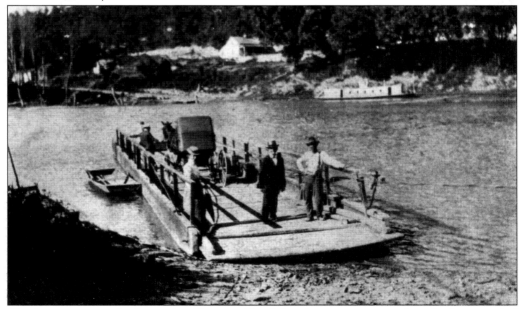

Coming to rest on the Jessamine County side of the river, one can see that the ferry carried foot passengers as well as carriages across the river. Early ferries were propelled across the river by oars, while later ferries were operated by hand-cranked paddle wheels, steam, and eventually diesel-powered engines. (Courtesy Shaker Village of Pleasant Hill Archives.)

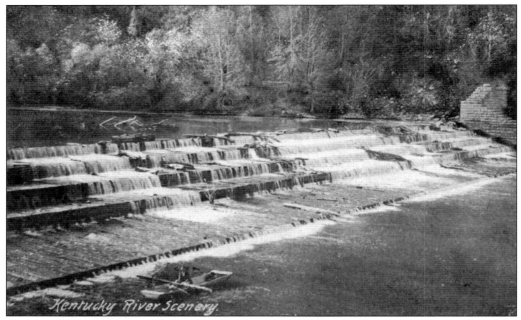

Built in 1896–1897 as part of a project by the Army Corps of Engineers to make the Kentucky River navigable along its entire length, Lock and Dam No. 7 is located near High Bridge and the Shaker landing. (Courtesy Ken Houp.)

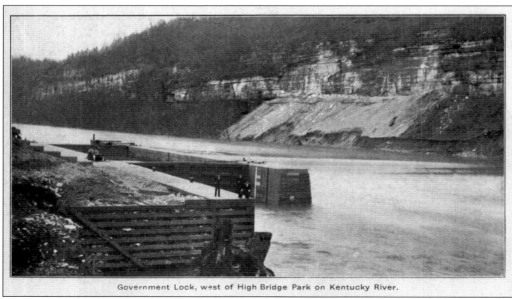

Government Lock, west of High Bridge Park on Kentucky River.

Because of Lock and Dam No. 7, the river was now navigable year-round and not just during a flood tide. In this view of the newly completed lock and dam on the right hand side of the photograph one can see the pile of silt dredged up from the river and left on its banks in Mercer County. The silt washed away over time. (Courtesy Ken Houp.)

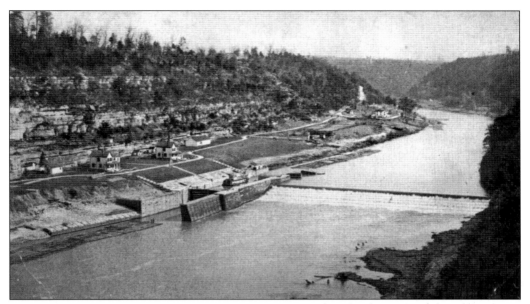

Lock and Dam No. 7 required the Corps of Engineers to purchase land from families and businesses alike due to the fact that the water table would be raised. In this view of the lock, one can see new homes that were built along the river, including the home of the lockmaster.

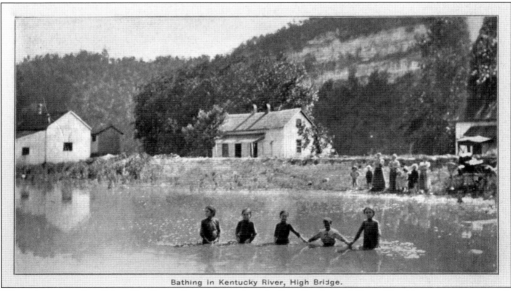

Bathing in Kentucky River, High Bridge.

This photograph of the Stephens farm was taken before Lock and Dam No. 7 were constructed. It demonstrates the shallowness of the riverbed, as the children are in the middle of the river and the water is only waist-high. The family relocated before construction began because after the lock and dam were completed most of their farm would be under water. (Courtesy Ken Houp.)

Jedidiah D. "Dug" Hughes owned and operated the High Bridge Lumber Company with business partner Willies Alcorn. The sawmill site would be displaced because of the construction of Lock No. 7. However, Hughes did not want to sell out to the Corps of Engineers. Negotiations ensued to no avail, and the land the High Bridge Lumber Company occupied became the only land the Corps of Engineers had to condemn by exercising eminent domain, forcing Hughes to relocate the mill. (Courtesy Clyde Bunch.)

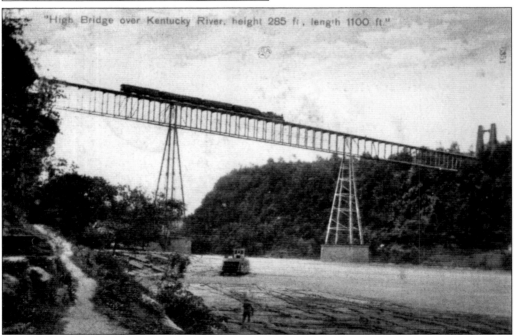

Logging was once a big business on the Kentucky River. Loggers from as far away as Barbourville would float their logs in rafts to be sold to sawmills. The logs were branded for identification before they made their journey, but occasionally, logs were missed. People along the river would search for unbranded logs, claim them, and sell them. The High Bridge Lumber Company was the first sawmill loggers would encounter on their route. (Courtesy Anna Armstrong.)

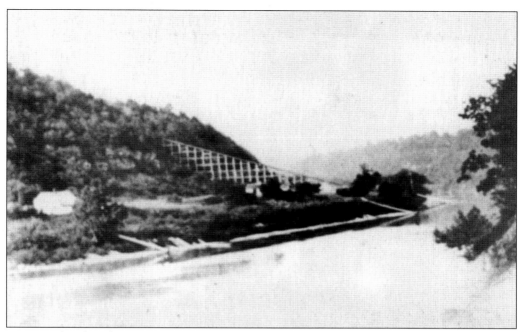

Because of Lock and Dam No. 7, High Bridge Lumber moved to land atop the cliffs. A log tramway was constructed to carry the logs from the river up to the sawmill. Area native Ken Houp recalls a tale his grandmother told him of finding an unbranded log as a little girl. Not wanting to lose it to someone, she rode the log up the tramway to the sawmill, where she sold it.

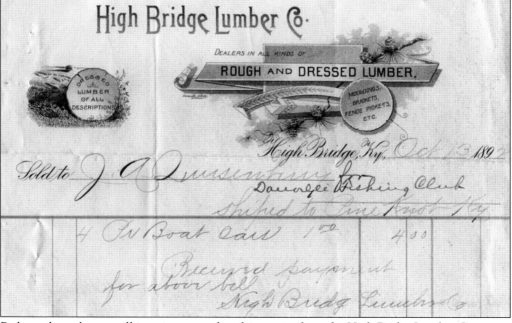

Perhaps the only one still in existence today, this receipt from the High Bridge Lumber Company to the Danville Fishing Club is dated October 13, 1892, wherein the club purchased four pairs of oars made by the company for a total cost of $4. (Courtesy Ken Houp.)

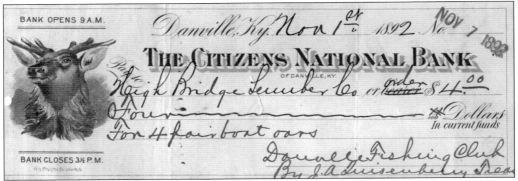

As a companion to the receipt, this is the check written out by the Danville Fishing Club to the High Bridge Lumber Company for the purchase of the oars. The draft was payable on the Citizens National Bank, signed by J. A. Quisenberry, and the check was presented for payment at the Citizens National Bank in Danville on November 1, 1892. (Courtesy Ken Houp.)

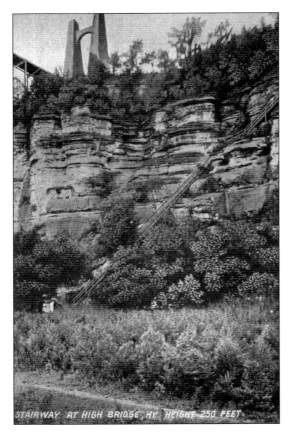

To reach the river below, visitors to High Bridge Park originally had to travel a distance outside the park and descend a cliff-side road. Wanting to make it easier for patrons to reach the river bottom to swim, fish, and marvel at the height of the bridge below, in May 1902 a plan was devised to build stairs from the park down the side of the cliff.

High Bridge resident Professor Barstow led the movement to build the stairs down the face of the cliff. The staircase was presumably made of lumber from the High Bridge Lumber Company. Obviously for brave souls, the staircase consisted of 271 stairs and was completed in August 1902.

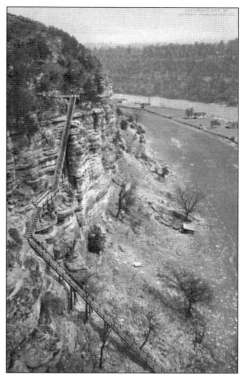

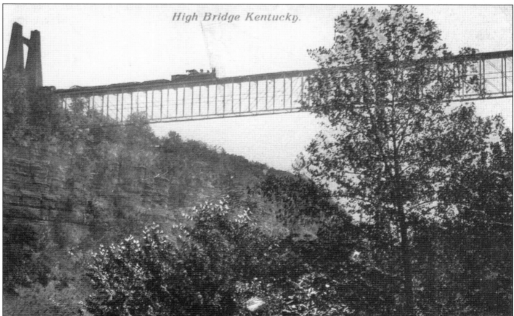

Throughout its life, High Bridge has been crossed by regular folks and notables alike. One such notable person was Prince Henry of Prussia, who crossed the bridge on his way to visit Louisville in March 1902. Upon word of the impending royal crossing, many residents turned out to catch a glimpse of his train as it passed. (Courtesy Anna Armstrong.)

The Old Wilderness Road followed the riverbank on the Mercer County side of the river, and it also led to the Shaker Ferry Landing. Along the road many cabins could be found. The road was also an ideal setting for visitors to the area to hike along the river and enjoy the view of the towering palisades and the bridge.

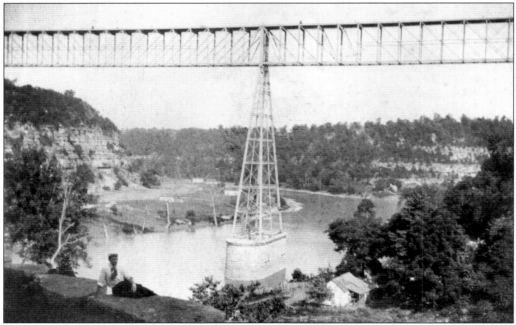

This unique vantage point on the bridge was taken from the Mercer County side of the river, on the bluff just above the Shaker Ferry Landing. Visible is the tenant house at the landing on the right-hand side of the photograph and High Bridge Park at a distance. The gentleman in the photograph is unidentified. (Courtesy Joyce Hardin.)

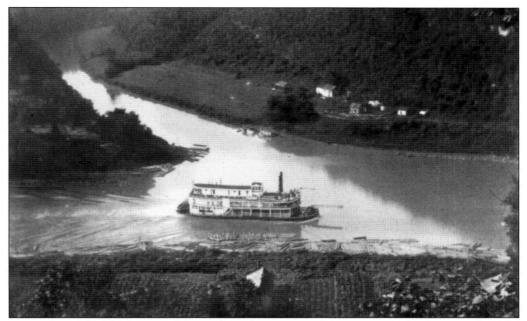

As word spread of the beauty of the High Bridge area, riverboat excursions became popular. The *Falls City II*, already a popular river excursion vessel, made weekly trips to High Bridge, sometimes bringing excursionists from as far away as Indianapolis, Indiana, and Benton Harbor, Michigan, who had traveled to Louisville for the sole purpose of boarding the vessel for a trip to High Bridge.

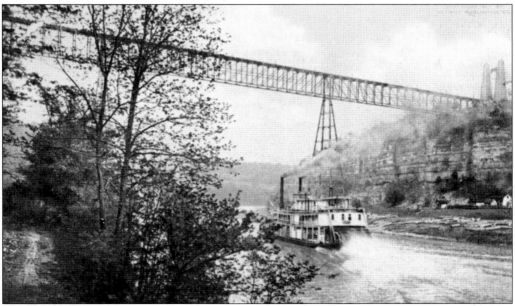

The familiar whistle blast of the *Falls City II* was a welcome sound to High Bridge residents. Due to the diligence of Capt. Squire Jordan Preston and Capt. Jonathan Newton Abraham, the sighting of the vessel could be predicted like clockwork. Even when the ship was not coming into port in the community, many in the area would run to the cliff edge or riverside to greet the vessel as it passed.

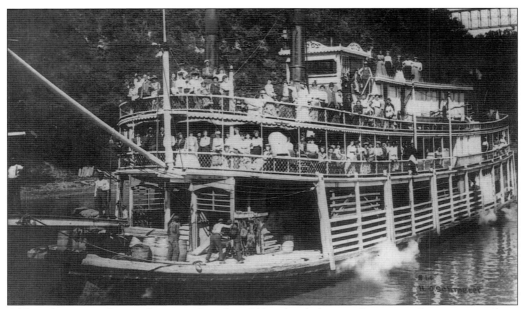

Although at times the conditions on board could be crowded, upon their return home excursionists would recount the fact that their minor discomforts were overlooked because the officers and crew were so "gentlemanly, clever and obliging." However, if one were late arriving at the landing, they were left behind because the ship's officers wanted to keep it as punctual as the train. (Courtesy Joyce Hardin.)

The Pepper family from Frankfort were among the many people to enjoy excursions to High Bridge on board the *Falls City II*. Excursions to High Bridge would often coincide with events held at High Bridge Park, such as the noted aquatic performer Captain Blondell. His show reenacted noted battles with model ships. All in attendance were promised a scene that was "realistic in the extreme" with his "costly models."

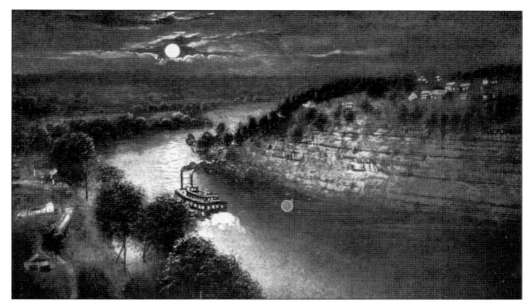

Night cruises were an alternative to the usual daytime excursions run by the *Falls City II*. In advertisements for such cruises, potential passengers were lured by promises of "an elegant outing free from all the annoyances of an excursion train, as well as the cool breezes of the river." The advertisement also claimed, "these torrid days require cool breezes in the evening to make good sleep at night."

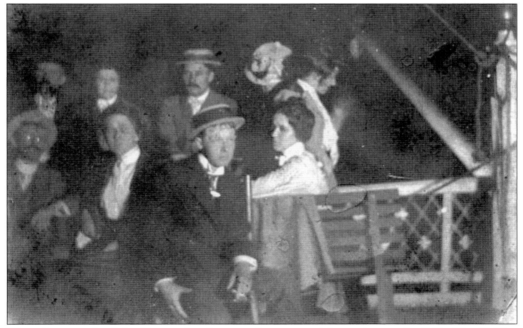

This photograph of the Pepper family was taken on a night cruise on the *Falls City II*. The excursions ran every few evenings and offered low rates to make it within the reach of all. The vessel furnished everything that was needed for the comfort of passengers on the excursions, which added to the experience and made it worth every cent paid.

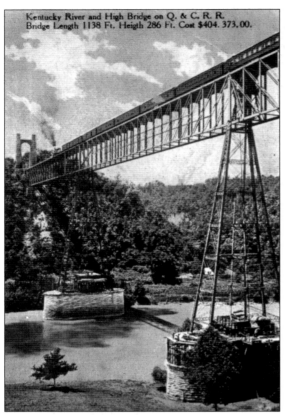

Kentucky River and High Bridge on Q. & C. R. R. Bridge Length 1138 Ft. Heigth 286 Ft. Cost $404. 373.00.

Tourists could also visit High Bridge by train. The Queen and Crescent Railroad and later the Southern Railroad heavily promoted train excursions from Lexington and Cincinnati to High Bridge. It was often billed as a "delightful place for boating, bathing, fishing, bicycling." Special fares were offered for these excursions. (Courtesy Ken Houp.)

A *Kentucky Gazette* advertisement dated July 5, 1899, read as follows: "Excursions are run from Cincinnati and all points south every other Sunday to High Bridge. There isn't a more beautiful place to visit than this entrancing spot. You can't afford to miss it. $1 from Cincinnati, 50¢ from Lexington and like low rates from other points. Ask your ticket agent about it. You cannot afford to miss this pleasant day on the river."

Excursion Special.

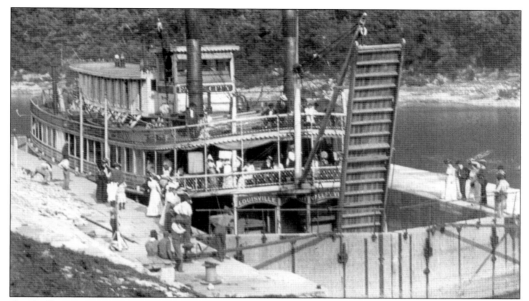

Circle Excursions were operated by the Queen and Crescent Railway in conjunction with the *Falls City II*, with fares ranging from $1 to $1.25. One could take the train from Frankfort to High Bridge, spend time in the park, board the *Falls City II*, and enjoy dinner, music, and dancing on a night cruise back to Frankfort, where one would disembark the vessel to one's respective train to return home.

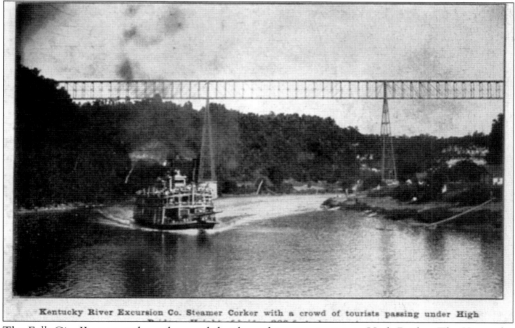

Kentucky River Excursion Co. Steamer Corker with a crowd of tourists passing under High

The *Falls City II* was not the only vessel that brought excursionists to High Bridge. The Kentucky River Excursion Company ran the *Corker* from Louisville to High Bridge on Mondays during the summer months on a six-day voyage. The fare was $25 per passenger, which included meals and berth.

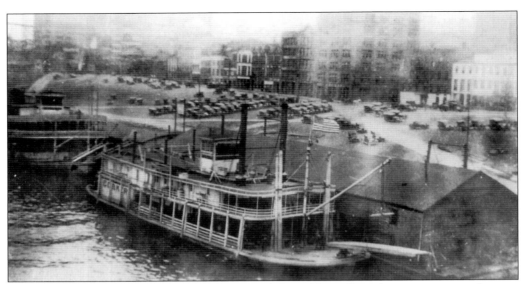

An advertisement postcard for the *Corker* invited the public to "spend your vacation with us on the Kentucky River, the Hudson of the West." It stated that the vessel was "safe and sound and as large as locks will permit, navigated by competent and courteous officers. Good clean berths [and] the best the market affords to eat. Reservations, accompanied by fare, must be made at least fifteen days in advance." (Courtesy www.RiverboatDaves.com.)

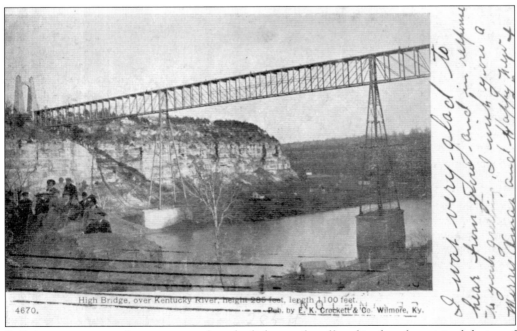

Built just strong enough to accommodate the lighter rail traffic of its day, the original design of High Bridge was becoming outdated. Questions arose about the safety of the structure. These concerns signified the beginning of another era for the community that would change its face forever. (Courtesy Ken Houp.)

Six

THE NEW HIGH BRIDGE

When Charles Shaler Smith designed High Bridge in 1876–1877, he could not have envisioned the heavy trains with increasingly heavy loads that would cross the bridge on a day-to-day basis. It was apparent by the early 1900s that the old bridge was not up to the job, and a project was undertaken to build another bridge. The American Bridge Company of New York was contracted for the job under the supervision of Curtis L. Dougherty, the chief engineer of the Southern Railroad. However, like the original builders of the bridge who were faced with the challenge of the cliffs, these engineers faced their own challenge: how to replace the bridge without interrupting rail travel. An interesting solution to the problem was devised by engineer Gustav Lindenthal. They built the new structure *around* the old bridge. Work began on the area around the bridge in 1908, and work on the bridge itself started in 1910. The new High Bridge was completed in 1911, and the first train crossed the bridge amid great fanfare.

The new bridge effortlessly carried traffic across the river, but once again, the bridge needed modification. This time it was not for structural reasons but to accommodate more frequent rail travel. Plans were made to lay two lanes of track across the bridge, one for northbound travel and one for southbound travel. But this modification doomed the landmark towers that Jonathan Roebling constructed in 1854, and the portion that towered over the tracks was removed, and the stones were restacked to accommodate a roadway where the right-of-way once existed. To this day the bridge still remains in service and carries numerous trains per day.

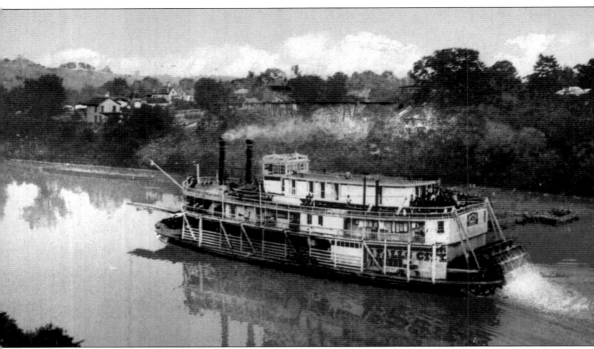

Much to the regret of many, due to a decline in demand for riverboat cargo transport and the fact that the profitable excursions on the river could not be held year-round because of weather conditions, the *Falls City II* was sold in February 1908 to Capt. Thomas Morrissey. He took her to Vicksburg, Mississippi, to replace his vessel the *Rosalie M*, which foundered in a storm in Mississippi some weeks before. The last sighting of this majestic boat that was once the best on the Kentucky River was in 1916, when it was seen abandoned in a Mississippi shipyard, falling apart.

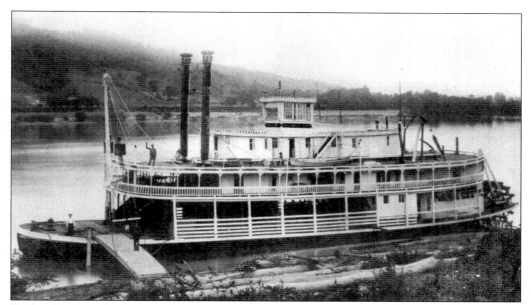

Under the control of Capt. Charles B. Williams, the *Park City* replaced the *Falls City II* after it was sold in 1908. The passenger accommodations were said to be far superior to those of the *Falls City II*, and its excursions to High Bridge were well attended, if not short-lived. The vessel struck a snag in the Kentucky River and sank on December 9, 1909. Fortunately, the crew escaped, and no passengers were onboard. (Courtesy Joyce Hardin.)

Seen here relaxing at home in High Bridge, James Robert "J. R." Preston, brother of Capt. Squire Jordan Preston, operated a general store that served the High Bridge area for many years. J. R. Preston's motto was that he would always give each and all a fair deal. He also supported local farmers by purchasing their produce to sell in his store. (Courtesy Amalie Preston.)

A May 26, 1909, *Jessamine Journal* newspaper mention of Preston's General Store stated, "J. R. Preston desires to announce to his many friends and customers that he has received, and is opening a large stock of foreign and domestic dry goods, notions, white goods, shoes, hats, etc. for the spring trade and he desires them to call and inspect same. He will quote prices most tempting however, this doesn't mean he has in any way abated his attention to his line of the best staple and fancy groceries." The man in the photograph is unidentified. (Courtesy Amalie Preston.)

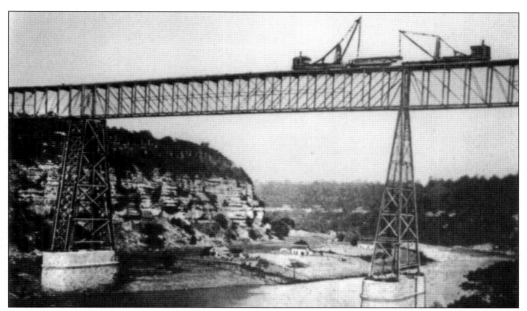

Before the new bridge could be built, its existing stone and steel piers had to be reinforced with additional steel and concrete to support the weight of the new bridge. Work began on the stone piers on April 24, 1910. In this view from May, the built-up stone piers have been completed, and two cranes are atop the original bridge in preparation for the work on the reinforcement of the steel bridge support piers. (Courtesy Anna Armstrong.)

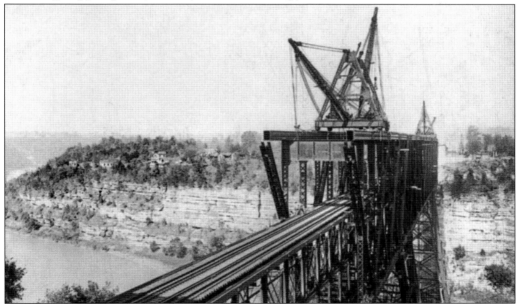

This view shows the unique method of the construction of the new bridge around the old bridge. Until the opening of the new bridge in September 1911, trains would cross the old bridge while work on the new structure was going on above them by the American Bridge Company. The new bridge's track would be 31 feet higher than that of the old bridge and wide enough to accommodate a double track, should one become necessary.

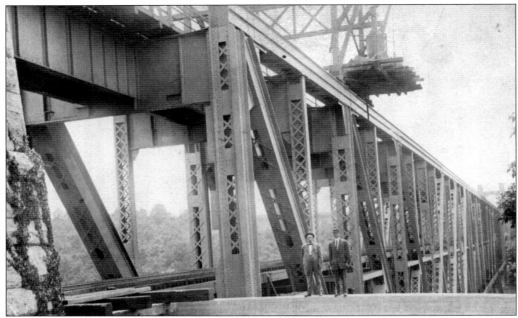

These two gentlemen are perhaps part of the group of 25 students who came from the College of Mechanical Engineering from Kentucky State University on October 28, 1910, to High Bridge. They observed the construction of the new bridge, standing atop the concrete wall that one sees today, which runs on the side of the roadway underneath the bridge at the top of the cliff along the cliff edge.

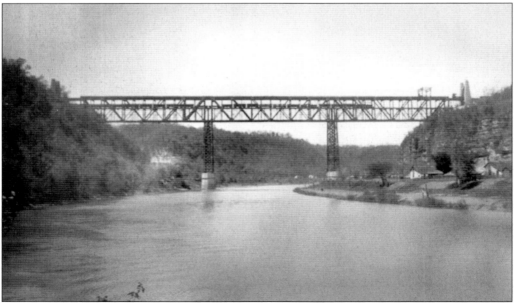

Nearing completion, one can appreciate in this distant view the train that goes across the old structure inside the new bridge. Imagine how the bridge workers felt when a train was rumbling across the bridge mere feet beneath them! Although unnerving for the workers, this was necessary so the railroad's service was not interrupted.

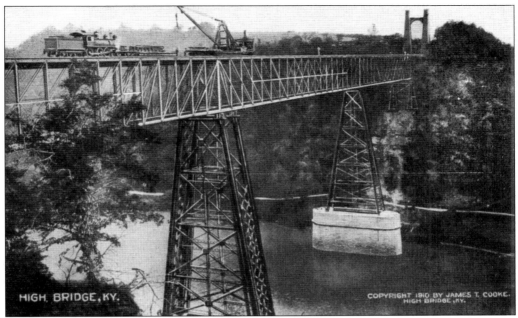

HIGH BRIDGE, KY.

COPYRIGHT 1910 BY JAMES T. COOKE.
HIGH BRIDGE, KY.

While some decried the replacement of the bridge, many applauded it, and great crowds would come to High Bridge daily to watch the work on the new bridge. The most popular viewing time was in the early morning and early evening hours because of the sparks from the rivets and rivet forges.

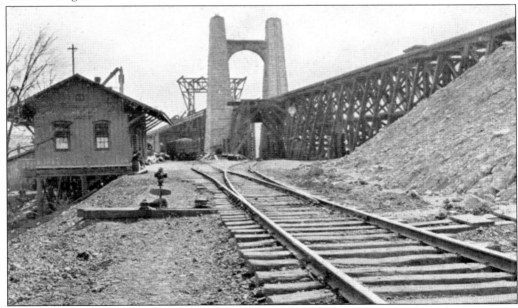

To accommodate the elevated track for the new bridge, a trestle was constructed and filled to add strength to the wooden structure. Note that the depot seen in this photograph is the original Victorian depot that once stood to the right of the bridge. Relocation became necessary because of its proximity to the tracks. When moved, the ornate Victorian woodwork was not reapplied to the depot.

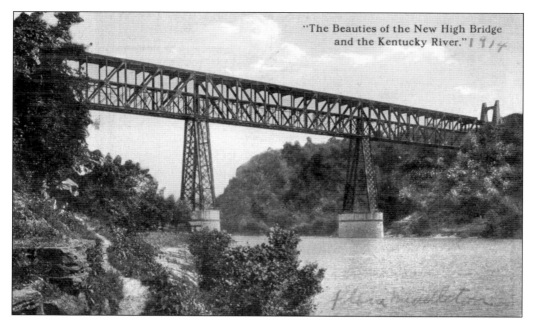

"The Beauties of the New High Bridge and the Kentucky River." 1914

After more than a year, work on the new High Bridge was completed in September 1911 at a cost of $1,250,000. The first scheduled train to cross the bridge was on September 11, 1911, and the opening of the new bridge was greeted by as much fanfare as the opening of the original bridge.

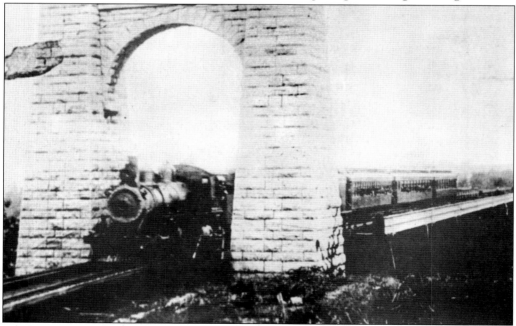

Heading south from Mercer County, locomotive engineer Clarence C. Horn took the first train across the bridge on September 11, 1911. Horn was chosen due to the fact that during his 14-year career on the rails, he never had an accident. Born in Harrison County on February 2, 1878, Horn was called the modern-day Hercules by many because he stood 5 feet, 10 inches and reportedly weighed 455 pounds.

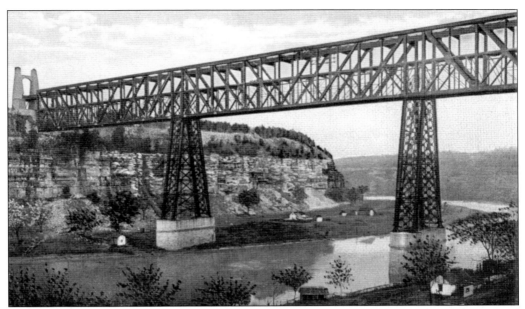

Not long after the new bridge opened, talks began on what to do with the portion of the original bridge that was to be removed from the interior of the new bridge. Judge George Kinkead proposed that the pieces be salvaged and then leased or sold to the Lexington Interurban Railway System. The pieces would be used to construct another bridge to carry Lexington's lighter, electric railroad. Kinkead's plan was rejected, and the original bridge was sold for scrap.

A popular means of communication at the beginning of the 20th century, many postcards were available depicting High Bridge on the front. Oftentimes after crossing the impressive structure, correspondence would mention the bridge. This 1908 postcard from Jim to Marcia, wherein his opening line states, "crossed this bridge twice this week. It is awful high," is typical.

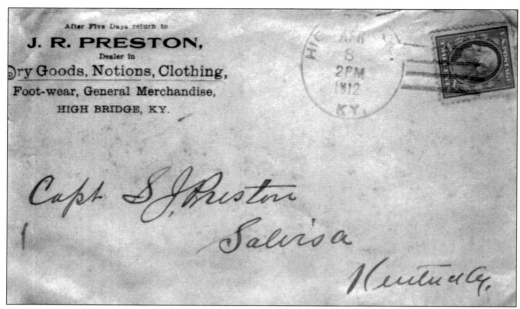

Advertising "dry goods, notions, clothing, foot-wear and general merchandise," this envelope, postmarked in High Bridge on April 8, 1912, from J. Robert Preston, is addressed to his brother, Capt. Squire Jordan Preston, who lived in nearby Oregon. However, by 1912, the post office in Oregon closed, and all mail was delivered to Salvisa, Kentucky, instead. (Courtesy Amalie Preston.)

Although many pieces of correspondence passed through the High Bridge Post Office until its closing in 1976, finding a surviving postcard with a High Bridge postmark is rare today. Prior to postmarking mail as being from High Bridge, the postmark would read Kentucky River Bridge, obviously during the bridge's construction, and North Tower before the community was renamed High Bridge around the time of the bridge's dedication. (Courtesy Ken Houp.)

84

Dix & Kentucky Rivers near High Bridge, Ky.

I am at the office & the boss thinks I am hard at work of course it is not good for the boss to know everything. Tell Selena she had better practice euchre a little more for you & I are going to put it on her & Barry the next time we play

Postcards offer a cameo of daily life at the turn of the 20th century. Part of this postcard, postmarked December 9, 1909, reads as follows: "I am at the office and the boss thinks I am hard at work of course, it is not good for the boss to know everything. Tell Selena she had better practice euchre a little more for you and I are going to put it on her and Barry the next time we play."

In what had to be one of the most elegant souvenirs of High Bridge, an October 9, 1914, newspaper advertisement for this spoon read as follows: "Mrs. Mattie Dorman McKee has designed and is selling a very beautiful and useful souvenir of High Bridge in the shape of a tea spoon. It is of oxidized sterling silver with plain bowl, but the handle is very beautifully decorated with a bust of Daniel Boone and a splendid etching of the new bridge with New High Bridge in raised letters. The design is truly a work of art and all who care for an inexpensive and useful souvenir can write to Mrs. McKee at High Bridge. The spoon has only been out a few weeks and Mrs. McKee has already received many orders." McKee's initials appeared on the reverse side of the spoon's bowl. (Both, courtesy Ken Houp.)

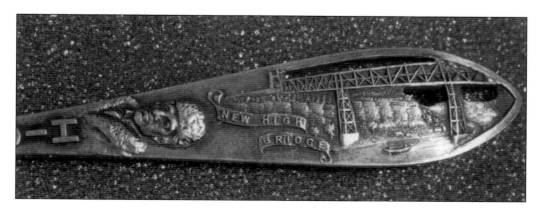

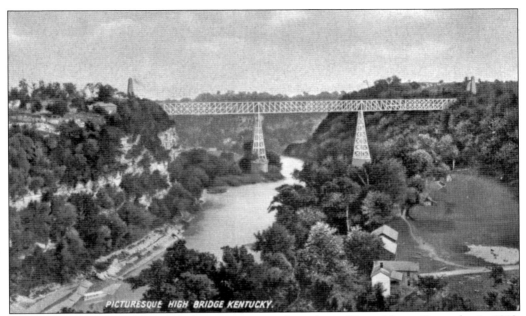

This image was painted by Ed Krakan, an artist and jeweler in Harrodsburg, Kentucky, in 1913. The image appeared on a tin sign that hung in every Southern Railroad train depot in Kentucky and showed the new High Bridge. On the back of the sign was a certificate with the bridge statistics. (Courtesy Ken Houp.)

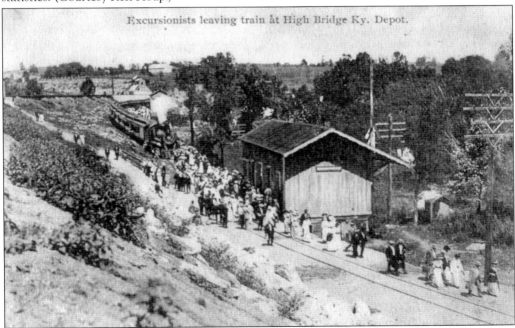

Taken from the elevation of the new bridge still under construction, this photograph of an excursion train with passengers debarking was taken c. 1910. The spur track was created for trains to pull off for passengers. It is still in existence as Old Saw Mill Road. However, the tracks have been removed, and the roadway only serves automobile traffic. (Courtesy Ken Houp.)

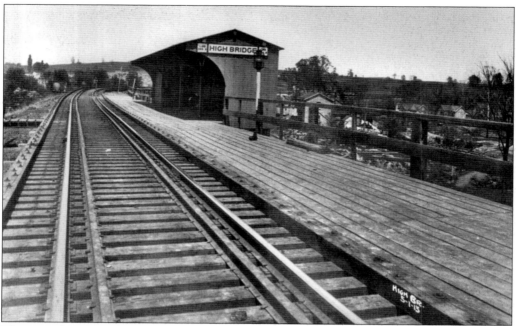

The second High Bridge depot was built farther down the tracks and stood at the higher level of the new bridge. The uninviting and plain structure lacked the warmth and ornate exterior trims of the original depot that had welcomed travelers for many years.

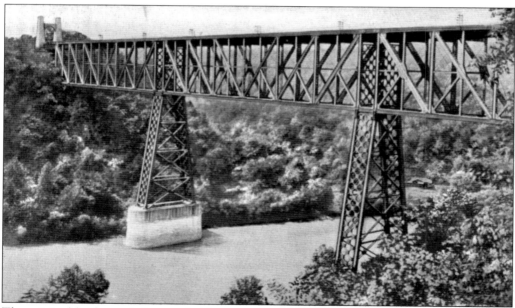

The original bridge and the new bridge were always painted every few years. But because of the massive size of the new structure that practice was stopped around 1915. The project was considered too expensive and too dangerous for workers because of the amount of rail traffic on the bridge and its height.

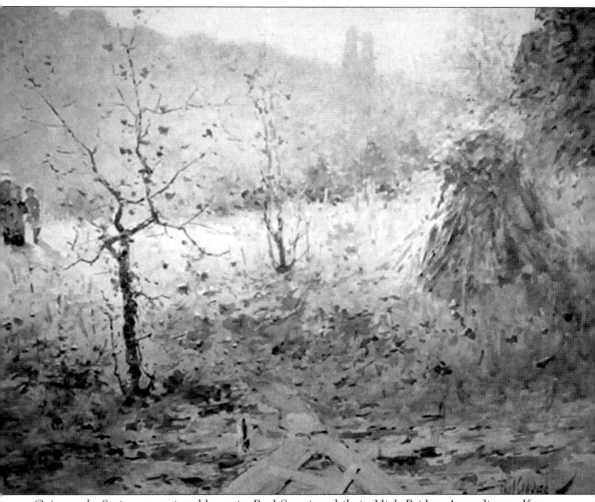

Going to the Spring was painted by artist Paul Sawyier while in High Bridge. According to Ken Houp, his great-grandmother Joanna Dearinger Beckham said Sawyier always told her he was going to include her in one of his paintings. But she did not believe him. On a visit to the spring with her daughter, Hadgie Beckham Horn, Sawyier was there painting. It is believed that they are the woman and child in this painting. (Courtesy Paul Sawyier Art Galleries.)

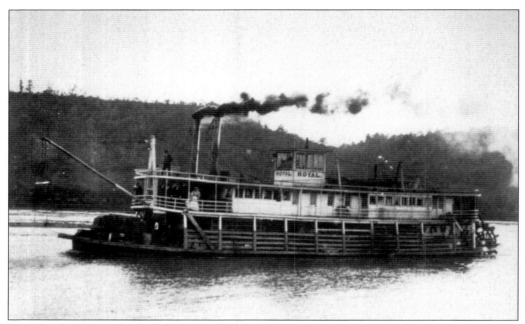

Launched in Golconda, Illinois, in 1904, the packet boat *Royal* came to the Kentucky River trade around 1915. One of its first orders of business was to offer excursions to High Bridge, normally bringing passengers from the Louisville area. In February 1918, the vessel struck the wharf in Madison, Indiana, and was taken out of service. (Courtesy Kentucky Historical Society.)

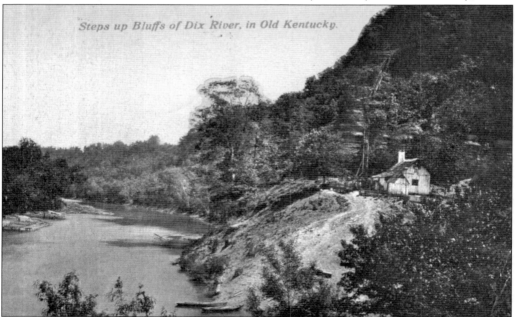

The popularity of the stairs down the cliff from High Bridge Park led other residents to do the same. One resident, Wash Hicks, built a small ferry landing on the edge of his property at the mouth of the Dix River. Hicks would bring paying passengers on his boat to stairs he had built up the cliff to visit a cave in the cliffs. (Courtesy Ken Houp.)

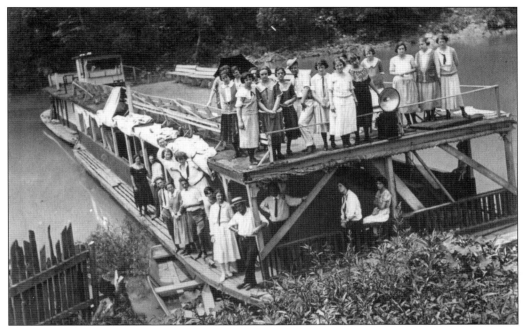

The *Chester* was one of the many locally constructed and owned excursion vessels made available for people who came to High Bridge by train, automobile, or steamboat to visit the area. Boats such as the *Chester* would often take passengers from the Shaker landing to the mouth of the Dix River and back. This photograph dates from 1922. (Courtesy University of Kentucky Archives.)

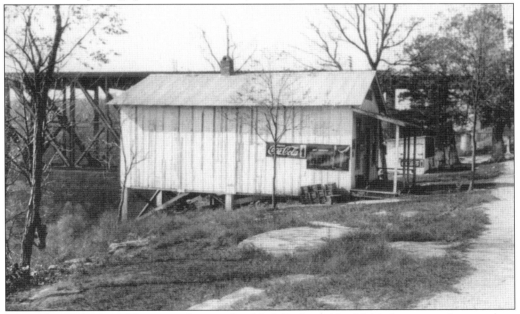

Located near the top of the stairs, this stand in High Bridge sold cold drinks to countless numbers of people on hot summer days, perhaps after they had just ascended the 271 stairs up the cliff from the riverbank below. Note the advertisements for Nehi Soda and Coca-Cola. The photograph was taken between 1924, the year Nehi Soda became available, and 1929.

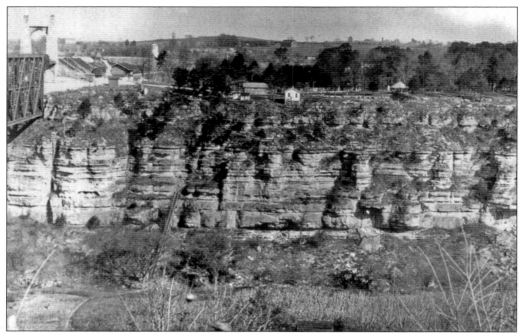

This is a unique vantage point looking from Mercer County across to the park in Jessamine County. On the far left of the photograph one can see the bridge and the depot in its new position. The building in the center of the photograph is the refreshment stand. One of the park's gazebos can be seen, as well as the stairs down the cliff face.

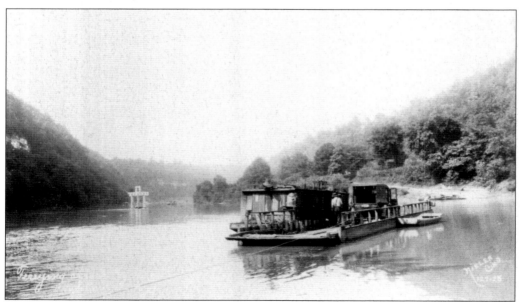

Seen in the distance in this view of the ferry operating at the Shaker Ferry Landing, Lock No. 7 was the only lock on the Kentucky River to have a self-contained hydroelectric power plant, which began commercial service in April 1928. The plant is still in operation but is limited depending on the stage of the river. (Courtesy Ken Houp.)

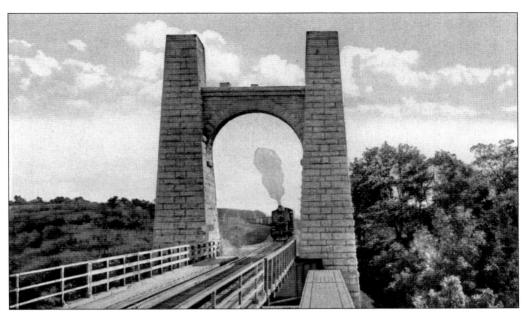

The raised level of the bridge gave Roebling's landmark towers a squatty appearance. The highest level of trains that crossed the bridge would pass about 10 feet below the arch connecting the two towers, which made some passengers and onlookers nervous.

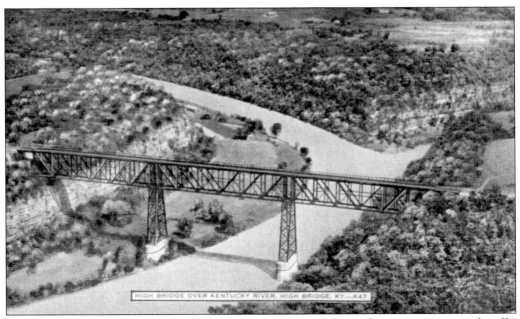

HIGH BRIDGE OVER KENTUCKY RIVER, HIGH BRIDGE, KY.—K47

The year 1929 brought even more changes to the structure. Due to a drastic increase in rail traffic crossing the bridge, a double track was laid across the bridge, one serving northbound traffic and the other southbound. To accommodate the double track, the landmark stone towers were cut down to the level of the track.

High Bridge's legendary stairway weathered the great flood of 1937 without sustaining major structural damage, only to be accidentally destroyed by railroad workers in 1948 who were burning brush along the riverbank. Due to the steady decline of visitors to the area, the stairs were never rebuilt. (Courtesy Anna Armstrong.)

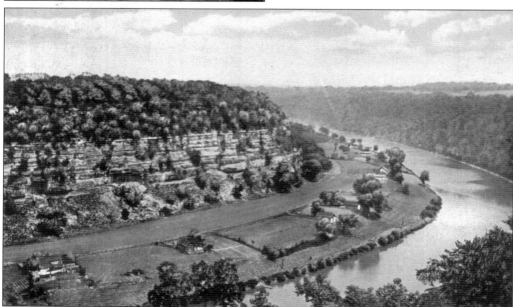

Seen here in the lower left, Ken Houp recalls many summer days spent at the home of his grandmother Hadgie Mae Beckham Horn in High Bridge while growing up. Her parents, Charles Beckham and Joanna Dearinger Beckham, had moved to High Bridge from the Cummins Ferry area in Mercer County many years before.

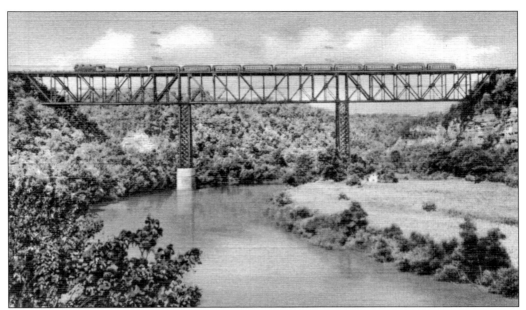

Ken Houp recalled a time when on the porch of his grandmother's home, there was a train crossing the bridge and blowing the tune "Shave and a Haircut" with its whistle. When he asked about it, she told him that it was her nephew Elmer "Bud" Horn. As a boy he had told her he wanted to drive trains across the bridge, and now that he was a train engineer, he would play the tune so she would know it was him crossing.

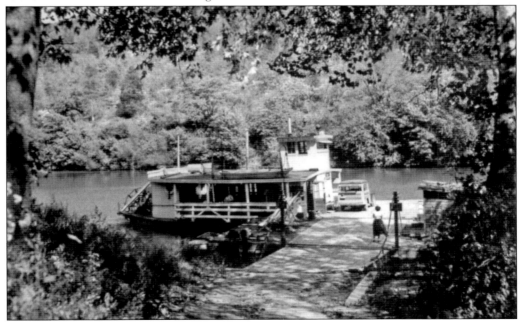

As horses and buggies gave way to automobiles, so the Kentucky back roads where ferries once operated gave way to more modern roads with bridges over waterways. The ferry that operated out of Shaker Ferry Landing was one such victim. This photograph was taken near the end of its operation on the river. (Courtesy Anna Armstrong.)

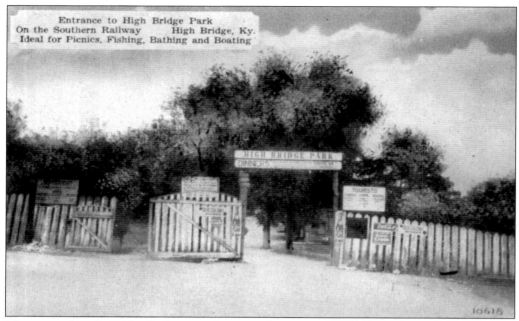

The gates of High Bridge Park greeted many sightseers, young and old, for generations. High Bridge Park was once a place for innocence. Over time and due to social changes, the clientele that frequented the park became rougher, and families quit frequenting the park. By the 1970s, the park was totally abandoned. (Courtesy Anna Armstrong.)

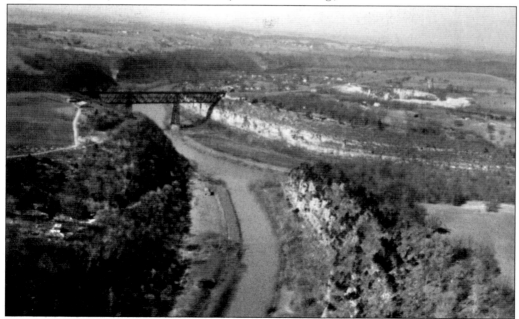

Today no passenger trains visit High Bridge, and the bridge only carries freight trains. Gone are the days of the steamboats that brought passengers from afar to see the steel marvel. Due to the closure of the locks and dams along the Kentucky River by the U.S. Army Corps of Engineers, the river itself is no longer completely navigable. (Courtesy Anna Armstrong.)

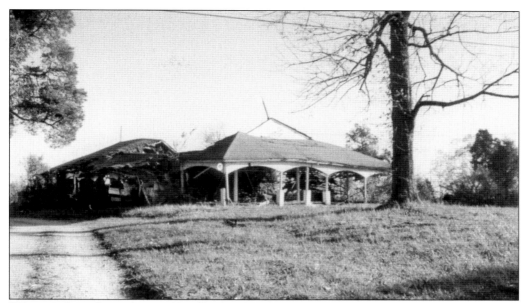

When High Bridge Park was officially closed in the 1970s, the structures in the park were left to the elements. Due to time, lack of maintenance, and vandalism, the old dance pavilion collapsed, perhaps longing for the days when dancing feet glided across its wooden floor and laughter echoed in its rafters.

This brass coat check tag is a reminder that High Bridge Park once hosted large gatherings and events of its day. Whoever had tag No. 92 must have retrieved their coat and decided to pocket the tag as a memento of their time in High Bridge Park. (Courtesy Ken Houp.)

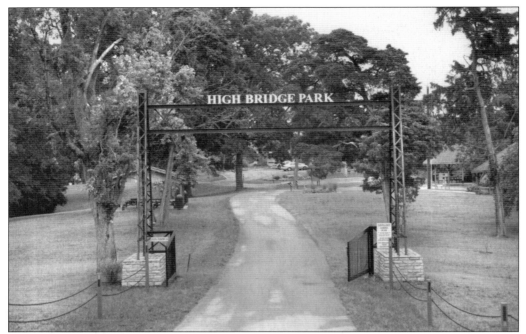

Beginning in the 1990s, interest in the park was renewed by local historians and politicians who wanted to preserve this treasure for generations to come. The park is open daily to the public, and once again it is a popular place for family reunions, wedding receptions, and picnics.

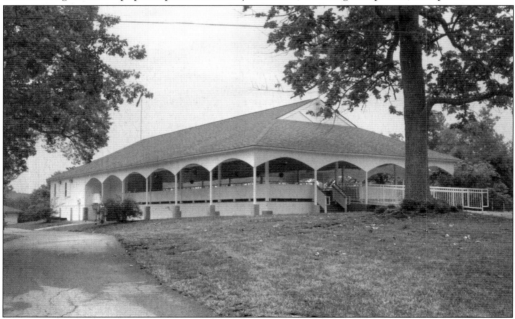

As part of the park's revitalization, the old, collapsed dance pavilion was razed, and a new pavilion was built that is identical to the original but with some modern updates. The park and new pavilion were officially dedicated on Saturday, May 13, 2000, with hundreds in attendance, including this book's author.

While it was widely reported that Roebling's stone towers were totally removed from High Bridge in 1929, the biggest portion, if not all of the towers, still remains in its original position. When the double track was laid, the stones above the bridge deck were relocated in a graduating stack to act as a barrier between the ballast and the roadway.

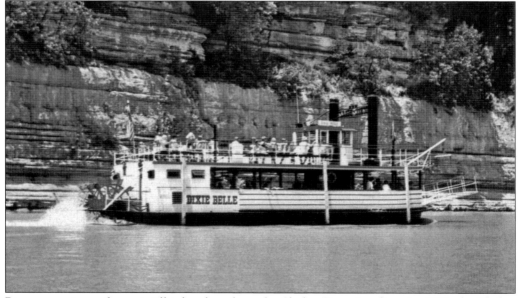

River excursions of a sort still take place from the Shaker Ferry Landing. In 1982, the Shaker Corporation purchased the riverboat *Dixie Belle* from Boonesborough and renovated it. It now operates one-hour sightseeing excursions between Memorial Day and Labor Day.

Besides the river and later the railroad, one attraction for the settlers in the High Bridge area was the abundance of the underground limestone springs. Today the springs still provide water that is bottled by the High Bridge Springs Company and is sold all over the state. To honor the engineering marvel that brought so many to the tiny village of High Bridge, the packaging gives a brief history of the landmark railroad bridge.

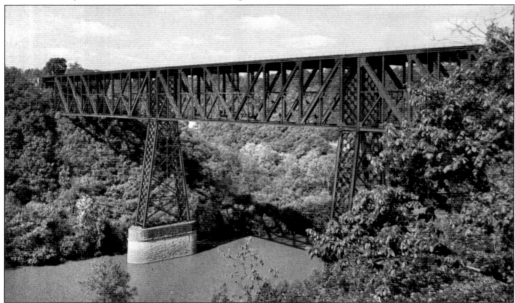

Approaching its 100th birthday, Gustav Lindenthal's High Bridge has withstood the test of time and will continue to carry the rails for years to come. This relic from the past still easily accommodates the heaviest of trains, with one crossing about every 20 minutes during peak hours, sometimes carrying a northbound and southbound train simultaneously. In fact, this bridge lies on the busiest north-south route on the Norfolk-Southern Railroad line in the nation.

Seven

CAMP NELSON

Named for Gen. William Nelson, Camp Nelson is a community that lies on both sides of the Kentucky River in Jessamine and Garrard Counties. Perhaps its most memorable claim to fame was the two-lane covered bridge erected by master covered-bridge builder Lewis Wernwag in 1838. During the Civil War, Camp Nelson became an important recruiting and training station for black Union soldiers. The covered bridge, which was only one of two bridges across the river in that area, was considered so strategic that a company of soldiers was stationed on each end of the bridge to prevent it from being burned by Southern soldiers.

In the years after the Civil War, the Kentucky River Distillery was established, and the distilling of spirits became a big business in Camp Nelson. In the 20th century, Camp Nelson began to fade into history. The Wernwag bridge was removed in 1933 and was replaced by a one-lane iron bridge. The realignment of U.S. Highway 27 bypassed Camp Nelson altogether, and the community ceased to exist. Now the only remnants that stand as a reminder to what Camp Nelson once was are the abutments of the old Wernwag bridge, its failing iron replacement, and the Camp Nelson National Cemetery.

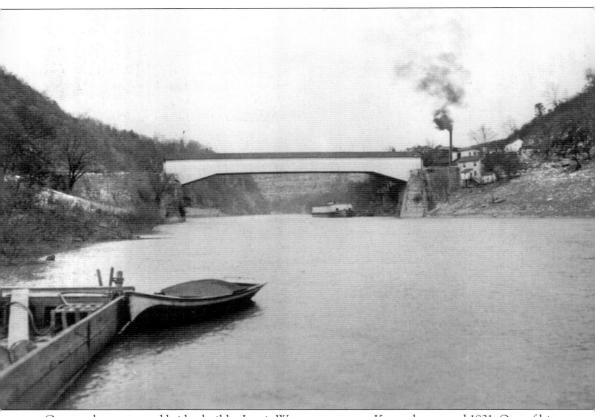

German-born covered bridge builder Lewis Wernwag came to Kentucky around 1831. One of his most famous covered bridges in Kentucky was at Camp Nelson. Built in 1838, the bridge was the longest single-span bridge known in the world. The bridge was 240 feet long with two lanes, each measuring 12 feet wide. The bridge was constructed for the sum of $30,000, with Jessamine and Garrard Counties splitting the cost evenly.

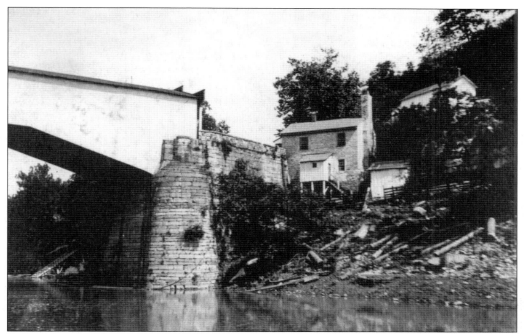

E. J. Curley established his distillery at Camp Nelson in 1875. In the early 1880s, he operated distilleries on both sides of the river. In their heyday, the distilleries produced 100 barrels of whiskey per day and had a mashing capacity of 1,100 bushels per day.

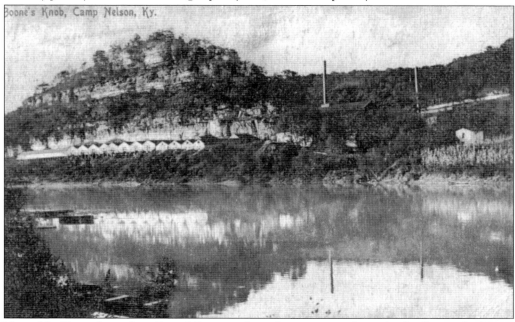

Named for Kentucky explorer Daniel Boone and seen here towering above the distillery outbuildings, Boone's Knoll in Camp Nelson looms high above the Kentucky River. This natural landmark is depicted in many photographs and paintings, as well as noted in several area writings. (Courtesy Ken Houp.)

Beginning in 1908, Kentucky artist Paul Sawyier lived in a houseboat on the Kentucky River for five years while painting scenes between High Bridge and Camp Nelson. His painting *Panther Ravine at Camp Nelson* was done from a north-facing vantage point. The Wernwag bridge is at the center of the community, and Boone's Knoll is seen in the upper right of the image. (Courtesy Paul Sawyier Art Galleries.)

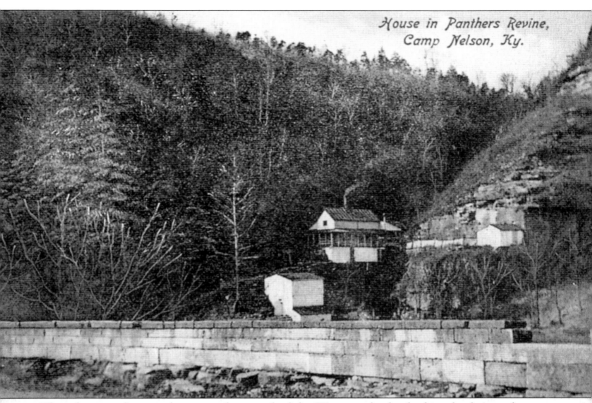

House in Panthers Revine, Camp Nelson, Ky.

This photograph was taken near the portal of the Wernwag bridge looking back into the area where Kentucky artist Paul Sawyier found the inspiration for his *Panther Ravine at Camp Nelson* painting. The origin of the name Panther Ravine is unknown. Paul Sawyier was friends with the manager of the Curley Distillery and spent much of 1912 in Camp Nelson.

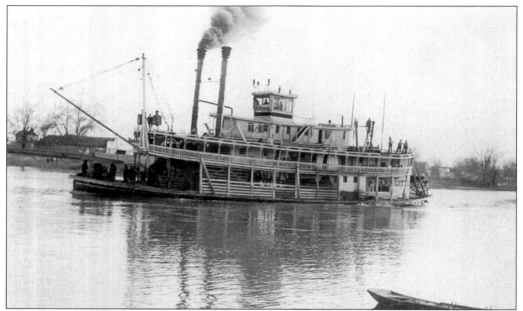

The owner of the *Park City*, the Kentucky River Transportation Company, advertised excursions on the vessel from Louisville to Camp Nelson for $8, including meals. On the three-day, 200-mile journey, passengers could enjoy a leisurely trip on the river, viewing the scenery that has caught the attention of people from all over the country.

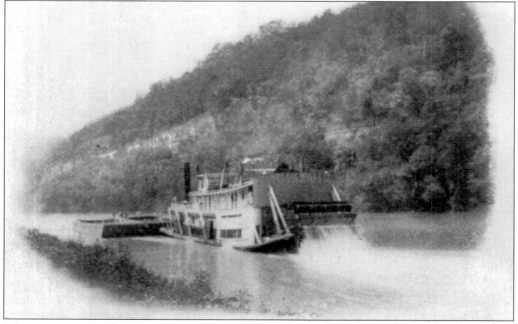

Like many vessels of its time, the packet boat *Nellie Willett* made weekly trips to Camp Nelson carrying both passengers and cargo. An advertisement in the *Jessamine Journal* from March 4, 1910, advised that the boat left Louisville every Monday and arrived in Camp Nelson on Wednesday. (Courtesy Ken Houp.)

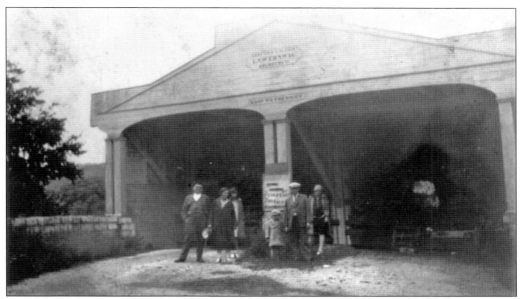

When a leaky roof was not repaired, subjecting the interior of the bridge to years of excessive moisture, a heavily loaded truck from Lexington broke through the rotted floorboards of the bridge in early 1926. Although closed to traffic, the bridge itself still drew visitors who wanted to see this engineering marvel. The sign on the portal of the bridge reads, "Ferry 200 yards back to right."

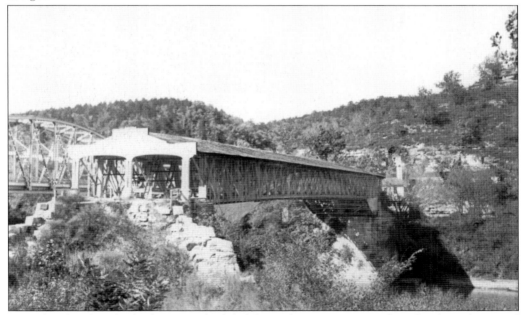

Immediately after the bridge was scheduled for replacement, outcry from local residents and state historians to save the bridge began. In March 1926, a largely attended meeting was held on the banks of the Kentucky River in which a Judge Hobbs from Lexington pled to the Highway Commission, "do not pull up the work of the genius of our pioneers. Do not destroy a structure built by the men who helped make our commonwealth."

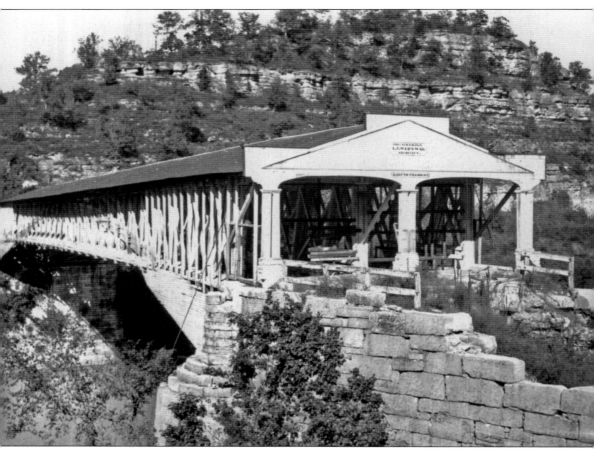

Covered bridge builder and repairman Louis Bower surveyed the bridge and submitted a proposal to make the bridge safe for modern traffic. After his proposed repairs, Bower offered to visit the bridge every 30 days to inspect it for the first year. At the end of the first year, he stated he would subject the bridge to rigorous testing to check the integrity of the bridge. His offer was refused, and the bridge was demolished in October 1933.

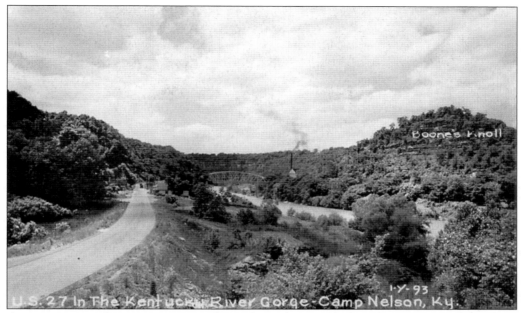

A portrait into a bygone era, pictured is U.S. Highway 27 before the present road was built bypassing Camp Nelson, the E. J. Curley Distillery in operation, and traffic still crossing the narrow steel bridge. Straight ahead in the distance one can just make out some of the businesses that existed in Camp Nelson.

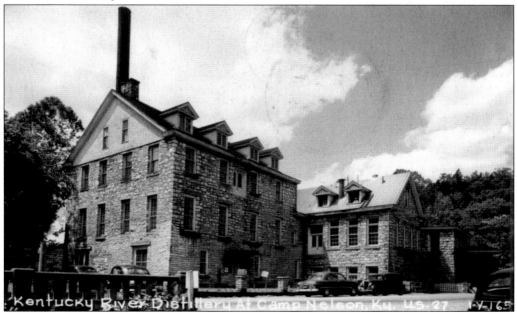

Locally known as the Great Stone Manor, this building was the largest in the complex of limestone buildings that made up the E. J. Curley Kentucky River Distillery. Over time, the distillery also produced Canada Dry ginger ale and Old Fitzgerald. The distillery ceased operation in 1971, and there was talk of turning the manor into a hotel. However, the building was burned by vandals in 1972 and was totally destroyed.

Even before U.S. Highway 27 was widened and realigned in 1972, it was still a major north-south route in the state. It was heavily traveled by stagecoach and carriage, and would eventually give way to the automobile. Unlike today's road, travelers wound their way down the palisades toward the Kentucky River and marveled at the scenic gorge views. They would pass through the shade of the Wernwag bridge and, in later years, would cross the river over its 1928 replacement.

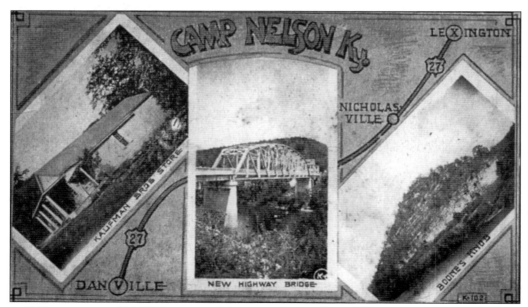

A 1940s-era postcard highlights some of the attractions in Camp Nelson against a map of what is today known as Old U.S. Highway 27. Pictured on this postcard is the landmark rock formation Boone's Knoll; the Kaufman Brothers Store, a typical country store of the era; and the bridge across the river.

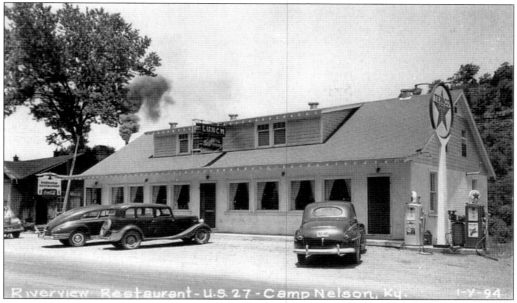

Riverview Restaurant - U.S. 27 - Camp Nelson, Ky. 1-Y-94

Camp Nelson once supported many roadside businesses such as the Riverview Restaurant, which was in close proximity to the Riverview Tourist Court Motel. Many of the businesses were closed after a major flood swept through the area. Several buildings were all but destroyed and were never rebuilt.

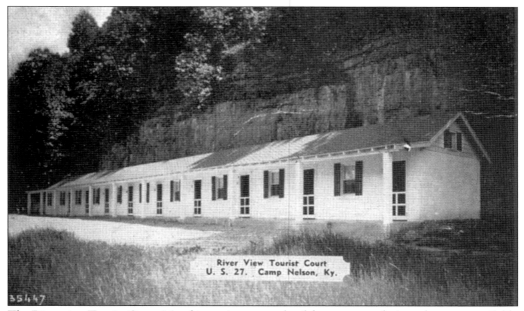

River View Tourist Court
U. S. 27. Camp Nelson, Ky.

The Riverview Tourist Court Motel is a prime example of the accommodations that were available to roadside travelers before air travel became commonplace and the automobile was no longer the choice mode of travel for family vacations. Because of its proximity to the river, guests could swim, fish, and boat during the day and retire to their rooms in the evenings.

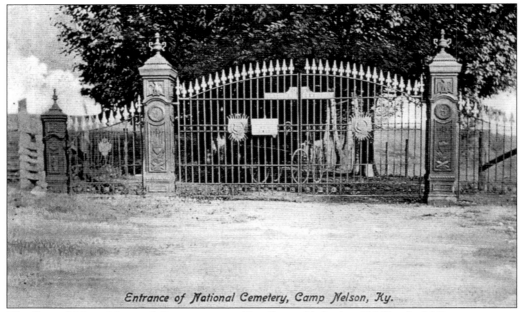

Entrance of National Cemetery, Camp Nelson, Ky.

The Camp Nelson National Cemetery was officially established in 1866 by the U.S. government. After the end of the Civil War, there was a federal government initiative to exhume remains of Union soldiers so they could be reinterred in national cemeteries. The cemetery has greatly expanded over the years, and it is still used for military burials.

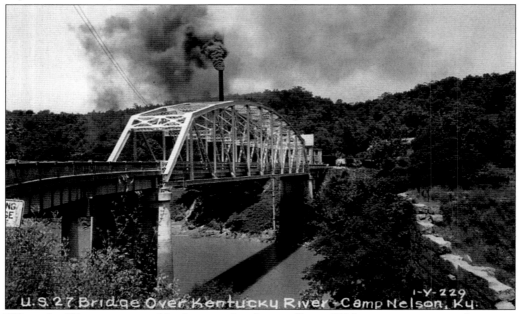

U.S. 27 Bridge Over Kentucky River - Camp Nelson, Ky.

When the Wernwag covered bridge was closed to traffic in 1926, construction soon began on the steel replacement span built adjacent to the covered bridge. The new span was completed and opened to traffic in 1928. The bridge remained open to local traffic until it was severely damaged in a flood in 1997 and subsequently closed to traffic. To the right of the steel bridge are the remnants of the abutments of the Wernwag bridge.

Eight

VALLEY VIEW

Although not officially established as Valley View until 1891, Valley View is home to the oldest business in Kentucky, the Valley View Ferry. In 1785, while Kentucky was still part of the State of Virginia, the legislature granted a franchise to John Craig, a Revolutionary War soldier, to operate a ferry between what are now Fayette and Madison Counties.

Valley View was the main river crossing-point for travelers between Lexington and Richmond, and many businesses were once established in Valley View. Valley View was also a popular destination for river excursion passengers on vessels such as the *Falls City II* and showboats.

Before the modern-day diesel-powered *John Craig* came into use at Valley View, many other, more primitive ferries were used, like the one shown in this undated photograph. The image, probably from the early 1920s, shows an oar-propelled craft. (Courtesy University of Kentucky Archives.)

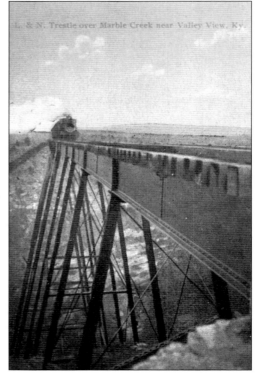

Built in the late 1800s to serve the RINEY-B Railroad, the Kentucky River Bridge carried rail traffic until 1932, when the line ceased operation. The railroad served the communities of Richmond, Irvine, Nicholasville, and Beattyville, hence the origin of the acronym RINEY-B.

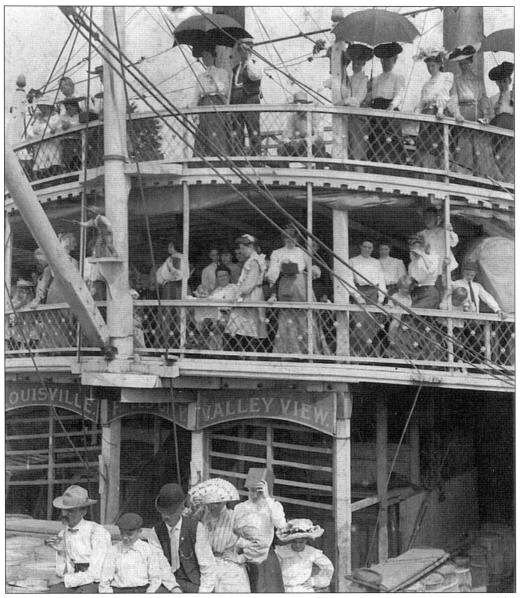

Valley View was the end of the line for the *Falls City II*. After visiting places along its route like Frankfort and High Bridge, the steamboat would come into port in Valley View. When its business was concluded there, it would turn around and head back to Louisville. An August 3, 1907, *Frankfort Roundabout* newspaper article read as follows: "The good steamer *Falls City II* brought up quite a good crowd of well dressed men and women on Tuesday. While the boat was unloading its cargo here the crowd too in all the points of interest, including both the old and new Capitals. Later they went on up to Valley View." It is believed that the woman seated near the center of the second deck is Capt. Squire Jordan Preston's wife, Celinda Jane Preston. (Courtesy Amalie Preston.)

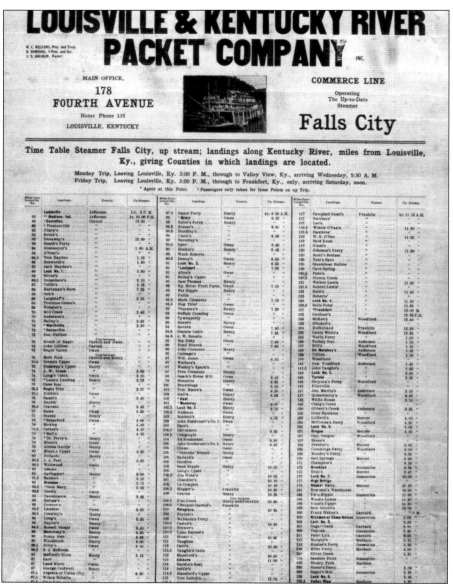

This timetable for the *Falls City II* indicates the numerous landings the boat serviced along the Ohio and Kentucky Rivers between Louisville and Valley View, and their mileage from Louisville. Including Louisville and Valley View, there were 246 landings listed. However, the ship would not stop at every single point on the schedule unless there was a scheduled pickup/delivery at a particular landing, or if persons on the riverbank flagged the boat to stop for them. The names of the landings would most commonly reflect the names of the property owner where the landing was located, like Tharp's, Dr. Perry's, and Hardin's, but they would sometimes be named for landmarks such as Hartman's Barn, Smoot's Cabin, or Bowman's Warehouse, and finally, communities such as Monterey and High Bridge. At 225.5 miles from Louisville by river, Valley View was the farthest point from Louisville that was serviced and was the end of the line for the vessel. Passengers traveling the entire route would embark on Mondays at 3:00 p.m. and arrive in Valley View Wednesday at 5:30 a.m. (Courtesy Kentucky Historical Society.)

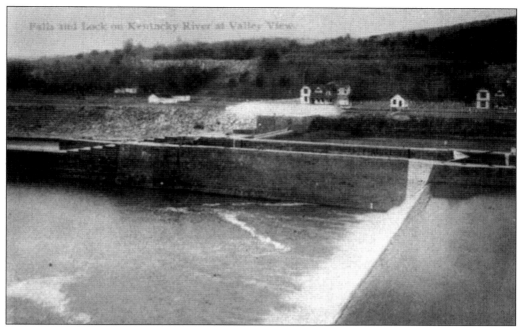

The construction of Lock No. 9 signaled a new era for the community of Valley View. Completed in 1903 by the Corps of Engineers, the lock was subsequently redesigned in 1905, and an auxiliary dam was added after the topography of the area around the lock was altered in a major flood.

A man of many trades, Capt. Edward E. Preston, shown here with his wife, Dora, served as lockmaster at Lock No. 9 in Valley View for many years. He was also in the shipping business with his father, piloting boats such as the *John A.* (Courtesy Amalie Preston.)

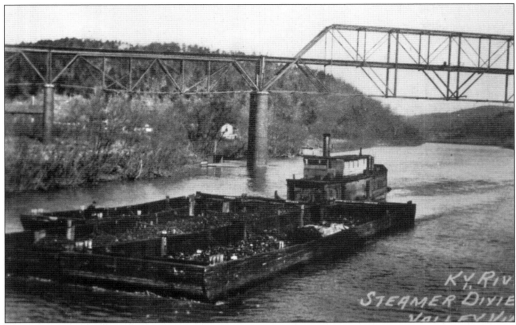

Shown passing underneath the RINEY-B railroad bridge that once crossed the river at Valley View, the towboat *Dixie* is shown here pushing a coal barge more than likely from the Beattyville area. Owned by the Frankfort Towing Company, the boat met its demise when it caught fire and sunk in October 1907.

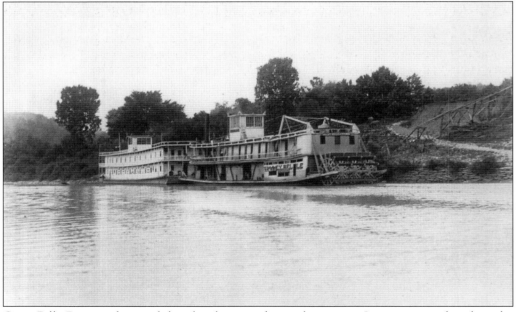

Capt. Billy Bryant often took his showboats as far up the river as Irvine in months when the weather was good. The showboats supplied the entertainment for Kentucky River folk and often would feature different shows on their return downriver to entice patrons to return. (Courtesy Kentucky Historical Society.)

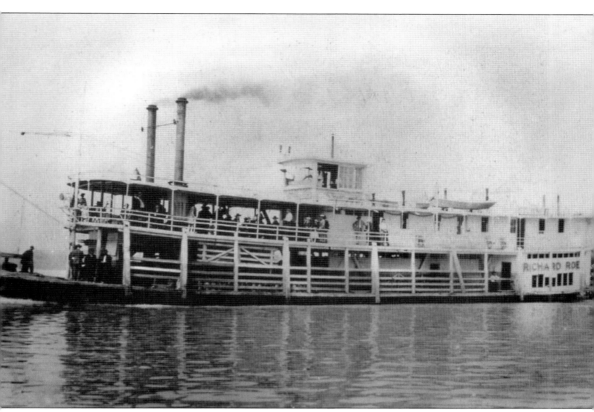

Ending its service in the early 1920s, the *Richard Roe* was one of the last steamers to operate on the Kentucky River. At the time it was owned and operated by Capt. William E. Roe for the Louisville and Cincinnati Packet Company. Like the other packet boats of its day, the vessel would carry passengers and freight, but near the end of its career, it mainly carried freight.

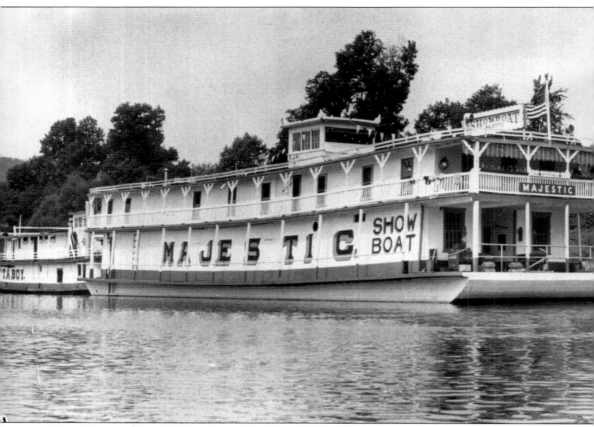

Capt. Thomas Reynold's showboat *Majestic* plied the Kentucky River on at least one occasion. The shows were a family affair, with the captain's children and grandchildren starring in and producing many of the stage shows. Born in 1935, Margaret King-Hudson was the last grandchild born on the boat. She recalled, "The loud calliope that my mother played . . . the wonderful smell of popcorn and candy . . . [and] the sound of the river waves lapping on the hull of the boat." (Courtesy Margaret King-Hudson.)

In 1890, the Optimist Club of Lexington established a campground for its members near Valley View on the Kentucky River. This photograph is from c. 1904 and depicts the Wilson family in a typical camp set up for the day. (Courtesy University of Kentucky Archives.)

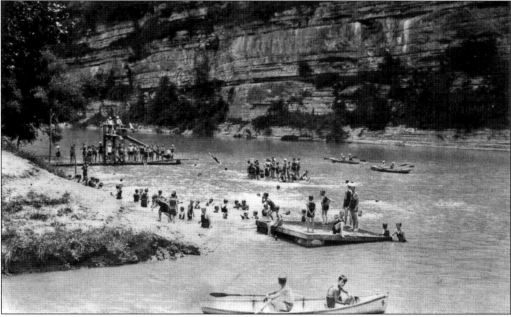

Named for Daniel Boone, Camp Daniel Boone came into existence after the property was purchased in 1920 from the Optimist Club of Lexington. Operated as a YMCA summer camp until the early 1970s, swimming and canoeing in the Kentucky River were two of the most popular camp activities enjoyed by children who relished their time away from home and school.

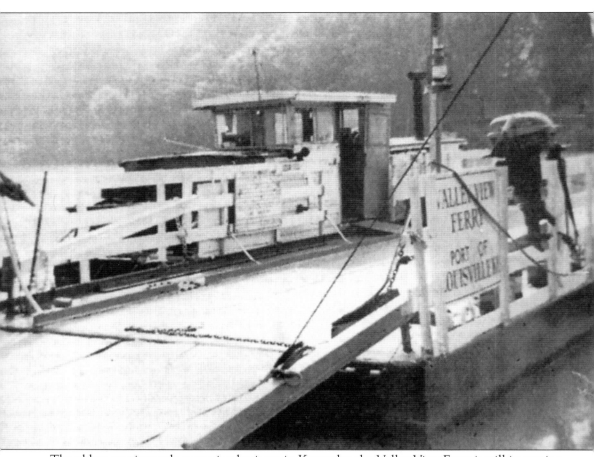

The oldest continuously operating business in Kentucky, the Valley View Ferry is still in service to this day. Operated by many in its 210-year history, it is currently operated by the Valley View Ferry Authority and serves seven days a week, with the occasional interruption in service for maintenance or because of river conditions.

Nine

Clays Ferry

The community of Clays Ferry can be found near the mouth of Boone's Creek on the Kentucky River on the Fayette and Madison County line. A ferry operated at the site, but because of the unpredictable nature of a river, it could not be operated year-round. In 1869, it was decided that a more dependable means of traversing the river was needed, and the first bridge at Clays Ferry was constructed that same year.

As traffic demands on the bridge increased, once again it was determined that the Clays Ferry bridge needed to be updated to alleviate the congestion caused by the one-lane bridge. Cars could not cross the river going each direction simultaneously.

In 1941, a new road was developed (U.S. Highway 25), and construction began on a new bridge accommodating two lanes of travel approximately a quarter mile from the original bridge. This bridge can still be found across the river. However, in 1963, a twin span was constructed to accommodate the north-south flow of traffic for Interstate 75, which had reached the area, requiring U.S. Highway 25 to be rerouted. Once again, due to an increase in traffic, the twin Clays Ferry bridges were altered. In 1998, lanes were added to each bridge, forming today's six-lane structure.

Throughout its history, the community of Clays Ferry has also evolved from what was once a quiet stagecoach stop to that of a busy stop, supporting many businesses at the intersection of U.S. Highway 25 and I-75.

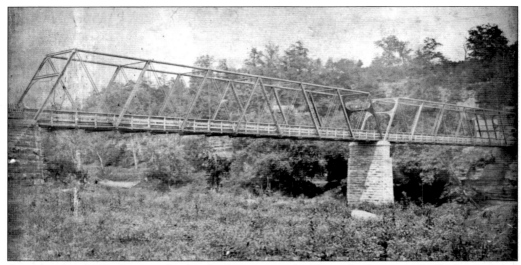

Completed in 1869, this was the first bridge to cross the Kentucky River on the Richmond and Lexington Turnpike at Clays Ferry. The 443-foot, one-lane Warren truss structure was originally a toll bridge. Rehabilitated in 1955, the bridge carries local traffic for those whose trip does not necessitate travel on nearby I-75. (Courtesy University of Kentucky Archives.)

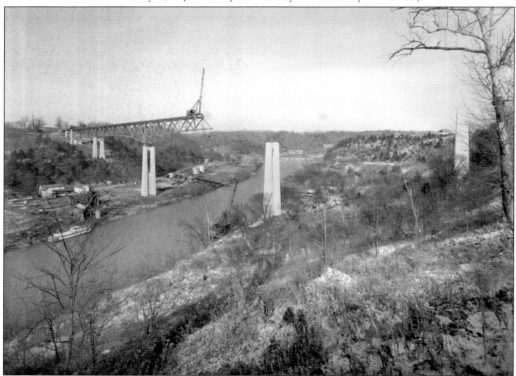

Before I-75 was developed, there was a movement across the Commonwealth of Kentucky to make the state's roads safer. A new bridge and highway were planned, U.S. Highway 25, that bypassed the original bridge and such dangers as Devil's Bend. Work began on the new structure in 1941. (Courtesy University of Kentucky Archives.)

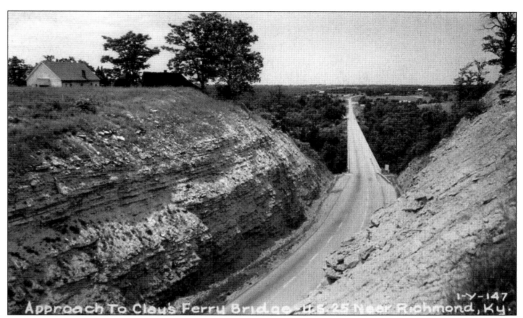

Although construction started in 1941, progress on the new U.S. Highway 25 bridge lagged due to the escalation of World War II. Work was eventually completed on the bridge in 1946, and its grand opening was held on August 17, 1946.

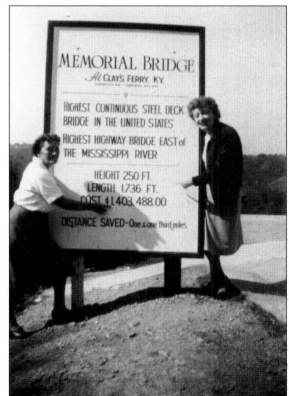

At the time of the opening of the new Clays Ferry bridge, it was the highest highway bridge east of the Mississippi River and the highest continuous steel deck bridge in the United States. As these ladies are pointing out in the photograph, the bridge cost $1,403,488 to construct.

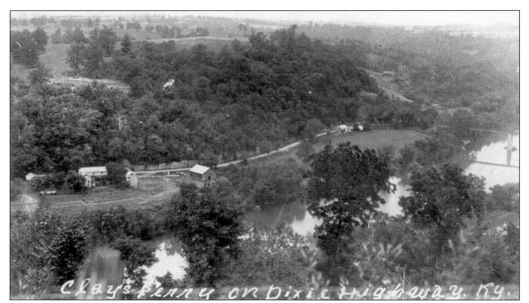

In 1956, the Federal-Aid Highway Act of 1956 was authorized, changing the face of roadways in Kentucky and the United States into the interstate system seen today. The course for Interstate 75 was plotted through Kentucky, and the community of Clays Ferry was directly in the path of the major north-south thoroughfare that was to be developed in the state, beginning in 1960.

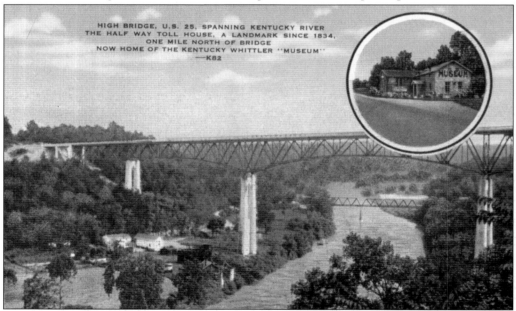

When I-75 reached Clays Ferry in 1963, an interesting decision was made. Rather than building two new bridges for I-75 to support the flow of traffic across the river in each direction, U.S. 25 was slightly rerouted, and I-75 utilized the existing span across the river. A twin was built beside it to accommodate traffic traveling in the opposite direction. The spans were widened in 1998, and a single, six-lane bridge now carries I-75 and countless travelers across the Kentucky River on a daily basis.

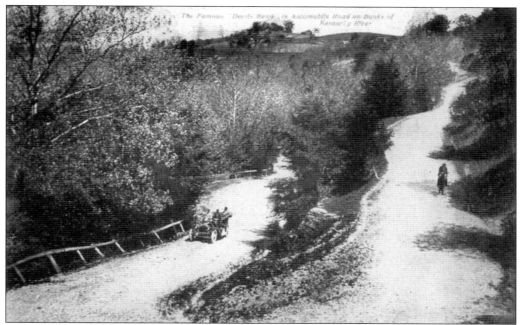

Most of today's drivers who cross the Clays Ferry bridge on I-75 on a daily basis are not aware of the dangerous road that once existed on the Richmond and Lexington Turnpike. Automobiles would wind their way down the cliffs along the river to cross the original one-lane Clays Ferry bridge. There is no doubt that Devil's Bend claimed many lives.

While the rerouting of U.S. 25 could have necessitated a new bridge solely to carry U.S. 25, an entrance/exit ramp was created for access to the interstate bridge, keeping the bridge accessible to the area residents, businesses, and others traveling on the rerouted U.S. 25. An added benefit of this entrance/exit ramp was the increase in commerce to the area from travelers on the interstate stopping for gas or food.

ACROSS AMERICA, PEOPLE ARE DISCOVERING SOMETHING WONDERFUL. *THEIR HERITAGE.*

Arcadia Publishing is the leading local history publisher in the United States. With more than 4,000 titles in print and hundreds of new titles released every year, Arcadia has extensive specialized experience chronicling the history of communities and celebrating America's hidden stories, bringing to life the people, places, and events from the past. To discover the history of other communities across the nation, please visit:

www.arcadiapublishing.com

Customized search tools allow you to find regional history books about the town where you grew up, the cities where your friends and family live, the town where your parents met, or even that retirement spot you've been dreaming about.